constructive context

An exhibition selected from the Arts Council Collection by Stephen Bann

© **Arts Council of Great Britain** **1978**

© Text: *Stephen Bann* Exhibition Organiser: *Karen Amiel* Exhibition Assistant: *Alison Brilliant*
Photography: *Cory Bevington, Prudence Cuming Associates Ltd, John Hunnex, ICI Plastics Division, Anthea Sieveking, John Webb*
Catalogue design: *Alan Stewart* Printing: *C.T.D. Printers Limited*, Twickenham, England

ISBN : 07287 0157 X

Foreword

The Arts Council's collection of contemporary British art has been formed in a variety of different ways. In recent years it has been the practice to invite artists, writers or critics to buy towards an exhibition on a theme of their choosing. A modification of this practice was introduced in 1977 when we asked the art critic William Packer to select from the purchases made by the art department itself. The result was the exhibition *A Free Hand* which is now touring regional galleries. At the same time we invited Dr. Stephen Bann to choose an exhibition from recent acquisitions in the constructivist idiom and to recommend further purchases in this area if he wished. The present exhibition, although small in scale, provides a very useful, selective survey of recent Constructivist and Concrete art in this country. We should like to thank Dr. Bann for his work on the exhibition and for the informative introduction he has written to the catalogue. The participating artists are also to be thanked for providing much additional catalogue material.

J. D.

The participating artists are :

Gillian Wise Ciobotaru Norman Dilworth John Ernest Anthony Hill Malcolm Hughes Michael Kidner Tony Longson Peter Lowe Kenneth Martin Terry Pope Keith Richardson-Jones Jean Spencer Jeffrey Steele Susan Tebby Chris Watts

Arts Council
OF GREAT BRITAIN

CONSTRUCTIVE CONTEXT TOUR

1978	
29 March – 19 April	Artists Market, Warehouse Gallery, London
6 May – 27 May	Royal Museum, Canterbury
7 June – 23 June	Polytechnic Art Gallery, Newcastle
4 July – 29 July	Turnpike Gallery, Leigh
12 August – 2 September	Dundee Museum
9 October – 29 October	The Gallery, Falmouth School of Art
4 November – 25 November	UCNW Oriel Bangor Art Gallery
1979	
2 December – 6 January	Museum and Art Gallery, Reading
13 January – 10 February	University of East Anglia, Norwich
19 February – 10 March	University Art Gallery, Nottingham
	Later showings not yet determined

Introduction
Dr. Stephen Bann

All of the British artists represented in this exhibition work within the terms set by the development of Constructivist and Concrete art during the past sixty years or so. That is to say, the emergence of forms of expression like the 'counter-relief' of Tatlin in the years preceding the Russian revolution, or the 'concrete painting' of the Dutch artist Theo Van Doesburg in 1930, holds for them more than a mere historic significance.[1] Implicitly they accept the type of argument advanced by Van Doesburg within the De Stijl movement, and reformulated by the American Charles Biederman is his immediately post-war *Art as the Evolution of Visual Knowledge,* whereby the development of man's visual sense and sensibility leads the artist inevitably to the acceptance of the constraints of 'abstract' form. Yet the connotations of the term 'abstract' are inappropriate here, in so far as they suggest a gratuitous impoverishment of the visual world in favour of the world of ideas and concepts. As the root 'construct' suggests, the constructivist never has far from his mind the sense of 'building' the work, with an often explicit reference to the human need for architecture which is embodied in that metaphor. As Hans Arp expressed it, the concrete artist does not 'abstract' something from the world, but brings something into it.

These British artists therefore accept a certain strict delimitation of the area in which they work. One could speak of them as existing within a tradition, as the classical artist has always done. Indeed the idea of tradition, with its natural assumption of a formal vocabulary handed down from one generation to another, fits well with the conception of an exhibition like this, in which the wide spectrum of ages rightly suggests that the younger participants have learned a great deal from their elders. But the note of tradition is not the only one, and perhaps not the important one, to be struck on this occasion. Tradition presumes the values of hierarchy and priority. It cannot dispense with the implication that what is being handed down was more perfect, less affected by entropy, when it was closer to the 'source'. What should be stressed in this exhibition is not the priority of the elders, but the very fact that artists of widely varying ages are engaged in connected activities. The 'constructive context' is made up of a whole range of differing practices. But the common elements which we can discover among them belong to the present, rather than to some ideal point of origin in the past. They also suggest an option on the future, in that the currents of investigation which are being pursued break continually into new and exciting territory.

It may be argued that, in suggesting a 'context' of this kind, I am saying no more than might be said of any group of artists who follow a particular 'style' — American Hyper-realism, for example. But the difference between such a 'stylistic' classification and the constructive commitment is, all the same, a crucial one. Obviously the works in this exhibition hold certain stylistic points in common : they could be identified as objects constructed or painted according to certain common principles of order, in the same way as Hyper-realist works could be identified by their common photographic or mimetic paradigm. But this would be a very inadequate way of explaining or justifying their overall effect. What emerges from the juxtaposition here, in many cases, of working drawings and the 'finished' art work is a widely shared concern to display the fabrication of the work as a *procedure* rather than a creation, let alone a mimetic replica. In drawing attention to the course of investigation which has 'generated' the work, the constructive artist reacts strongly against the tendency to view the art object fetishistically, as a detached object which concentrates the magical power of its creator. Quite the contrary, he suggests an affiliation not with magic but with science : with the patient process of hypothesis and experiment whereby the scientist tests and formulates his intuition of the physical world.

This is a parallel which would be welcomed by many of the artists included in this exhibition, and one which is evident from some of the statements published in this catalogue. On one level, it can involve them in activities which appear to lie outside the role of the artist as it has been traditionally conceived. To take only two examples, John Ernest's interest in topology has led up to a current project of realising in material terms the conceptual figure known as the 'Klein Bottle' : while Terry Pope's investigation of optics has resulted in the fabrication of a series of 'spectacles' which modify and enhance our perception of space. But apart from this obviously 'experimental' activity, there is a more general comparison to be made between the contemporary evolution of artistic and scientific practices. As Malcolm Hughes reminds us, a scientist like David Bohm has drawn attention to the fact that 'science, art and mathematics' have been 'moving in related directions, towards the development of what is, in effect, a mode of experiencing, perceiving and thinking in terms of pure structure, and away from the comparative, associative, symbolic method of responding mainly in terms of something similar that was already known earlier in the past'.[2] Anthony Hill, who has himself worked as a mathematician, has always taken care not to make unrealistic and pretentious claims about the constructive artist's involvement with science and mathematics, and he has tried to clear up some of the ambiguities which arise in a recent article. But he nevertheless raised the intriguing possibility, in 1970, of an 'application of the sciences (including mathematics and philosophy as well as anthropology and sociology) to the *Study* of Art'.[3] At this stage he described as 'particularly challenging . . . the notion that new data from aestheticians could and *should* become essential data both for the artist and for the users of art'.

Even if the artists represented here would give many different answers to the complex question of their involvement with science, there seems little doubt that this diversity would imply a common rejection of the traditional idea of creativity, and of the quasi-sacral 'aura' (in Walter Benjamin's terms) still valued by the Realist or Surrealist painter. The Constructive artist has traded in, so to speak, the notion of the individual masterpiece. What he has received in return is the assurance of a context, both artistic and scientific, in which his dialogue — with his audience, with his fellow artists and with his fellow scientists — can be carried forward.

The distinction is clarified by the example of Kenneth Martin, who is the senior artist represented here and who, with his wife the late Mary Martin, had a decisive influence in the propagation of British Constructivism in the post-war period. As Paul Overy has pointed out, Kenneth Martin's 'Chance and Order' series, begun in the late 1960s, formed a striking contrast to the assertive and self-indulgent productions of many other British artists of the period who were still possessed with the fantasy of the super-human creator encouraged by American Abstract Expressionism. No one could accuse the 'Chance and Order' series of smothering the traditional painter : indeed Kenneth Martin's constant attention to the surface values of the painting suggest a parallel far away in the past of Constructivism, in the dialectic of ideal and material values explored by Malevich. Yet the modest scale of the series, its close relation to the sets of preliminary drawings, and above all the fact that as a series it genuinely conveyed the impression of an activity of research which went beyond the terms of the individual work — all these factors helped to change the relationship of the spectator to the object which was before him. It was in no sense a question of responding, like a privileged voyeur, to the psychic grandeur which the artist had expressed on the canvas. It was a matter of dialogue. The spectator could participate in the testing of the relation between 'Chance' and 'Order' which is still the generative principle of Kenneth Martin's activity. [4]

The 'Chance and Order' series therefore demonstrates in an exemplary way the relationship which most of these artists seek to establish. In principle, the experimental or structural investigation which has led them to a particular object is not abandoned but remains recoverable : whether or not it is expressed in preliminary drawings, whether or not it can be grasped immediately, the 'track' which has been followed must be taken into account. But after making this general point, which is the point in common within the 'constructive context', I should proceed to explain some of the points of divergence. It would be wildly unrealistic to represent the tradition of Constructivism as a uniform, or unified development, which developed according to a succession of agreed moves and strategies. Indeed one of the most fruitful aspects of this tradition lies in its reiterated polemics, in its abrupt turns and transitions within a general field of practice and discourse. The British artists represented here take their places, as is inevitable, within the system of oppositions and affiliations which defines the present context of Constructivism. It is worth devoting some attention to the cross-currents of thought and practice which underlie their artistic production.

The work of Kenneth Martin has been cited as epitomising the principle of 'dialogue' with the spectator. I have also suggested that, in bringing the sheer plasticity of the painted surface into play, Martin obtains a distinctive interaction of form and content, idea and material which recalls the practice of Malevich. Anthony Hill, who began to work as a constructivist in the early 1950s and has a comparable stature as an artist, also seems to me to have carried on a fruitful interchange with the pioneers of the movement. But in his case, it is not a question of the material qualities of the painted surface, or indeed of the direct participation which Martin invites through his solicitation of chance. In the earlier part of his career, Hill's work could have been related to the precedent of Tatlin, contemporary and to some extent rival of Malevich, who initiated the notion of a 'material syntax' as the sufficient basis for the constructivist work of art. Like Tatlin, Hill used a wide range of industrial materials (perspex, aluminium, copper and formica, to name a few), although he gave a more effective significance to the notion of 'syntax' by his association of distinctive 'syntactic' elements in different groupings. Since 1974, however, Hill has not made a relief of this kind. In recent statements, he has indicated that his interest in the Russian avant-garde has shifted from Constructivism proper to the parallel movement of Formalism, which was largely developed by critics and poets yet made a valuable contribution to the scientific study of art in general which is still far from being fully assimilated. Obviously, for Hill, the retrospective dedication of a series of reliefs to the Formalist pioneer Khlebnikov is not intended as a kind of alibi, to deflect the spectator's attention to the prestigious citation. But it inevitably adds an historical and cultural dimension to the study of graph theory and symmetry which has been the continuing thread of his more recent work.

Both Kenneth Martin and Anthony Hill suggest the appropriateness of the term 'radical conservationist', as it has been applied by Gillian Wise Ciobotaru to the aspiration of the present-day constructivist. [5] Her own work from 1960 onwards also demonstrates simultaneously her concern for the values of tradition — the 'language' or languages in which constructivist art has its origin — and those of thematic or technical innovation. Just as she has taken an interest in Adrian Ciobotaru's reconstruction

from photographs of some historic components of the 1921 Obmokhu exhibition in Moscow, so she has consistently investigated the plastic effects obtainable from the displacement of geometrical structures into different dimensions and different media. The relationship which is maintained between the original figure or 'model' and its displaced image is thus comparable in at least one respect to the relation between preliminary drawing and finished painting in the case of Kenneth Martin. Both procedures establish an opening in space and time : the pictorial composition is not allowed to remain merely as an object with fixed boundaries. Indeed this concern to 'test' the properties of a model, rather than presenting a single definitive realisation, means that the work or sequence of works can offer unanticipated dividends. John Ernest, who has made relief constructions from 1954 onwards, explains his interest in topological figures like the Moebius Strip (the predecessor of his present project with the Klein bottle) in the following terms : 'One of the most intriguing things about models is that once a valid correspondence has been set up between the subject and its image, the model may reveal aspects of the subject not obvious to direct consideration . . . A diagram may be used as an empirical tool for discovering new properties in some conceptual structure.'[6] Although this point applies specifically to the highly complex task of rendering a figure like the Moebius Strip, it is also relevant to Ernest's use of group theory in the work on exhibition. Far from mechanically repeating a pre-existent concept or structure, constructivism can be in a real sense a technique of discovery — a source of new knowledge through aesthetic response to the material object.

Both Gillian Wise Ciobotaru and John Ernest took part in the Arts Council 'Systems' exhibiton of 1972, together with a number of other artists whose work is included in this exhibition. The fact is worth taking into consideration, since the overall context of the 'Systems' show indicated a shift from the original positions of Kenneth Martin and Anthony Hill as they have been briefly summarised here. 'Systems' was, by design, a wide-ranging didactic exhibition, which comprised contributions from a wide variety of British artists working in the constructivist and concrete tradition. It might be said to have placed this tradition under critical scrutiny, displaying it not only as a source for current activity but also as a problematic, a store of unresolved and fascinating problems about the nature of plastic expression. Malcolm Hughes, who played a leading role in organising the group which discussed and planned the Systems exhibition, contributes to this exhibition with an impressive work which underlines this critical and problematic relation to tradition. Working drawings emphasise the fact that Hughes is using a single procedure of selecting relations between numbers to obtain the physical structures of both relief and painting. Yet the fact that both relief and painting are present in the same composition (albeit dissociated by the neutrality of the matt black canvas which intervenes) creates questions about our perceptual, and conceptual, relationship to the common structure. Obviously for Malcolm Hughes, the assumption that the relief is a privileged and exclusive form of expression no longer holds good. By reintroducing the values of painting, the evidence of the careful testing of the equivalences of tone and hue, he draws an equation between the two types of material realisation solely on the basis of their physical properties. But the very fact of doing so subverts our assumptions about the distinct formal conventions of constructivist art.[7]

Other contributors to the Systems exhibition also represented in this selection include Michael Kidner, Peter Lowe and Jean Spencer. Kidner works essentially as a painter, whose refined sense of colour and texture is all the more telling for being submitted to the generative discipline of a formal procedure. He has drawn attention to the way in which an artist may think of himself as *creating* order, *discovering* order or *observing* order, and one suspects that the general direction of his work over the past few years has been away from the first mode, in the direction of the second and perhaps especially the third.[8] Peter Lowe and Jean Spencer have both concentrated to a great extent on the monochrome relief : Lowe uses predominantly cubic elements, which relate to one another through rigorous serial or permutational relations, while Spencer develops more complex serial structures from working drawings which have great charm and graphic sensivity. Within the bounds set by these contributions, a number of other exhibitors seem to find their place. Keith Richardson-Jones obtains an interplay between painterly sensibility and the discovery of order which recalls Michael Kidner. His extreme discretion, amounting to a kind of pictorial *litotes* or understatement, is symptomatic of the anti-expressionist character of constructive painting. Susan Tebby, with Peter Lowe a pupil of Kenneth Martin, contributes a permutational structure which, like Martin's mobiles, is at the disposition of the spectator. Recalling the exercises in participation which were attempted in the 1960s by the Israeli artist Yaacov Agam, this work reminds us that the confluence of constructivism with the 'kinetic' experiments of recent years has been in some respects a fruitful one. Terry Pope's impeccably finished constructions may also appear at first sight to relate to the optical research of kinetic artists, and their use of phenomena such as the moire effect. But this should not be allowed to conceal the fact that Pope has been working since the early 1960s on the refinement of particular constructional techniques which he has adapted to produce spatial and perspective effects of considerable sophistication. Two of Pope's

former students, Chris Watts and Tony Longson, are among the youngest artists represented in this exhibition. But while Chris Watts' successive diminishments of a numbered grid make a strong appeal to the instinct of play, Longson's incised and superimposed crosses on perspex are not simply ludic but offer themselves as clues in the construction of an imaginary space.

The reference to kinetic art, as an international and particularly European movement during the 1960s, reminds us once again that constructivism has never existed in a strictly and exclusively national context. Kenneth Martin, Anthony Hill, Peter Lowe and Terry Pope all took part in the debate on the status and direction of constructive art initiated by Joost Baljeu in his magazine *Structure,* which first appeared in 1958 and continued till 1964. It is perhaps true that British constructive artists, like British artists is general, prefer an individual stance to the specific commitments of a group programme. But Peter Lowe is now a member of the 'international work group for constructive art'. The 'international work group', which include a wide variety of European constructive artists and regularly invites others to participate in shows, undoubtedly attempts a more modest programme than the groups of the 1960s, with their heady and in the end somewhat self-destructive rhetoric. But its periodic symposia and its group exhibitions which focus on a particular plastic or structural theme provide valuable lines of communication in the European scale. Norman Dilworth's recent work would seem to belong within this European context, however indebted it may be to the British tradition. His exploitation of notions like the 'continuous line' in both two-dimensional and three-dimensional structures does not so much involve the spectator in dialogue and interpretation as present him with a definitive and paradoxical state of form : a relevant parallel is with some of the sculptural work of the immensely wide-ranging Swiss concrete artist Max Bill. A further contributor to this exhibition, Jeffrey Steele — who co-founded the Systems group in 1969 — has also taken his bearings from Swiss concrete art, although the most illuminating point of reference is not Bill but his fellow artist Richard Lohse. Steele, whose lengthy and patient elaboration of systematic structures had recently borne fruit in the triumphant expression of the 'Syntagm' series, defines the task of the constructive artist in terms which powerfully exercise our imagination :

'Combinations of elements of a kind which neither nature nor any other human activity can produce, and which for that reason are sometimes intrinsically very simple, act as messengers between the known and the unknown. But the message is a syntactic and not a semantic one. The process can be compared to trying to communicate by signals with an intelligence on another planet with whom we have no common experience and therefore nothing to communicate *about*. This must be the hidden, unconscious part of ourselves which has been variously postulated by art, mythology, philosophy, science — a system whose better understanding may contribute to our survival as a species.'[9]

This (for at least some of the artists represented here) is the Utopian project of contemporary constructive art. The artist sollicits not pre-existent social and cultural values, but the 'hidden, unconscious part of ourselves' which is the source of such present (and future) values. It may seem at first sight a modest activity compared with the exciting pursuit of direct social and architectural applications by the Russian, De Stijl and Bauhaus constructivists of the 1920s. And indeed it is a reiterated critical plaint that such artists as those represented here have abandoned the commitment which their predecessors so enthusiastically undertook in the heroic period which followed the Russian Revolution. Such an objection betrays, however, singularly little sense of the morphology of art — its necessary succession and supersession of forms — or of the artist's specific relation to his historical circumstances. To take a remote, but suggestive analogy, one could stigmatise Swinburne because he did not express the Utopian political message of Shelley, or indeed engage in the struggle for liberty which was the occasion of Byron's death. For such an argument, the early 'Ode to Mazzini' which Swinburne wrote in his youth would represent a possibility not followed, a direction unexplored. Yet the fate of Nationalism is unified Italy and unified Germany, which was the history of Swinburne's maturity, in effect left few openings for Romantic idealism. Swinburne's achievement lay in turning the political debate about liberty and bondage from the extrapolated dimension of nationalist politics to the internalised dimensions of psychological and familial structure.[10] Similarly one of the genuine dividends of constructive art at the present day is that it corroborates and extends the deepening knowledge of linguistic and psychological structures which is the underpinning of our contemporary map of knowledge. The constructive artist explores structure as *necessity,* in however close a relation to liberty. His final appeal, like the closing chorus of *Atalanta in Calydon*, is from within the bonds of a language, which he transforms in the very act of acknowledging its power :

NOTES

1. I take these two instances simply as representative of the multiplicity of forms, and attitudes, emerging within the general field of Constructivism at this period. A much more detailed survey can be found in the collection of documents, *The Tradition of Constructivism* (Ed. S. Bann, Thames & Hudson, 1974), which reprints many of the statements and manifestoes of the period. However it may be necessary to make a working distinction for the purposes of this exhibition between 'Constructivist' and 'Concrete art'. To put it crudely, original Constructivism incorporated the Russian artists Tatlin and Gabo, the Dutch De Stijl movement under Theo Van Doesburg and aspects of the work carried on at the Bauhaus. Concrete art, deriving from the manifesto published just before his death by Theo Van Doesburg, has been developed in the post-war period largely by Swiss artists such as Max Bill and Richard Lohse. While concrete art is genuinely a product of Constructivism, it has repudiated the central commitment of the constructivist artist to the construction. Both Bill and Lohse (like several of the artists in this exhibition) utilise the traditional painting on canvas as a privileged medium.

2. David Bohm, 'On the relationship of science and art', in *DATA* (ed. Anthony Hill), 1968, p. 171 : quoted by Malcolm Hughes in *Systems exhibition catalogue* Arts Council, 1972, p. 22.

3. Anthony Hill, 'A Structuralist Art ?','in *20th Century Studies*, 3, May 1970, p. 107. Cf. also 'A view of non-figurative art and mathematics and the analysis of a structural relief', in *Leonardo*, Vol. 10, pp. 7-12 1977.

4. Cf. *Chance and Order* (introduction by Andrew Forge), Waddington Galleries, 1973 ; also my review of Martin's retrospective at the Tate Gallery, published in *Studio International*, Sept. 1975.

5. Cf. her statement in *Systems exhibition catalogue, op cit.*, p. 57.

6. *Ibid.*, p. 19.

7. Cf. my article, 'Malcolm Hughes and the Open Book', in *Studio International* Sept. 1973.

8. *Systems exhibition catalogue, op. cit.*, p. 31.

9. *Ibid.* pp. 53-54.

10. Cf. introduction by Morse Peckham to Swinburne, *Poems and Ballads, Atalanta in Calydon*, Library of Literature edition, New York, 1970.

Who shall contend with his lords
 Or cross them or do them wrong ?
Who shall bind them as with cords ?
 Who shall tame them as with song ?
Who shall smite them as with swords ?
 For the hands of their kingdom are strong.

Gillian Wise Ciobotaru

Born 1936 London. While still at art school came across writings of Charles Biederman and through him to know Anthony Hill in 1959. From 1960 on, took part in a number of exhibitions of British Constructivism. Gained scholarships to Prague 1968 and Leningrad 1969–70 and has taught at the University of Illinois 1970–71, Chelsea School of Art 1971–78, Royal College of Art 1978.

Exhibitions include:
Construction: England 1950–60, Drian Gallery, London. 1963 *Relief structures,* Institute of Contemporary Arts, London (with Anthony Hill). 1965 8th Tokyo Biennale. *British Sculpture in the '60's,* Tate Gallery, London. 1967 Axiom Gallery, London. 1968 *Four Artists,* Victoria and Albert Museum, London. *Relief/Construction/Relief,* Museum of Contemporary Art, Chicago. 1969 Nuremberg Biennale. *System,* Amos Anderson Museum, Helsinki. 1971 *Four artists: Reliefs, Constructions and Drawings,* Victoria and Albert Museum, London. *Matrix,* Arnolfini Gallery, Bristol. 1972 *Systems,* Whitechapel Art Gallery, London. 1974 *British Painting,* Hayward Gallery. 1976 *Drawn from structures,* Polytechnic of Central London.

See also writings : 'Notes on the Art Work as an Object' in *DATA, Directions in Art, Theory and Aesthetics,* edited by Anthony Hill 1968. 'Quantities and Qualities' in *Leonardo, International Journal of the Contemporary Artist,* edited by Frank Malina, Vol. 1. No 1. 1968.

The following is a transcription of a tape recorded statement the artist made with Ralph Rumney in August 1976 in connection with her exhibition 'Drawn from Structures : 6 Themes 1967 to 1976' at the Concourse Gallery, Polytechnic of Central London, October 1976.

If I had to put in one word a definition of artistic process 'reification' still seems as good as when it was used by the Russian Formalists sixty years ago, an act of regarding an idea as a thing and by extension the act of making an idea into a thing. Here each drawing and print relates directly to a three dimensional object I've previously made or reified. The essential idea when made into a thing has to fulfil a criterion of mental translatability on two levels. One, the principles of its construction which are a series of elementary combinations and not usually obscure to the naked eye. Secondly the physical idea should be retainable in the mind when the work is no longer there, a kind of reification in reverse. Incidentally, in these drawings the scale is intentionally small, much nearer to that of a large book page than a wall field and so the emphasis is conversational rather than declamatory.

Since a drawing taken from a structure has to put the cross section of it into a pictorial space, (that is the imagined three dimensional 'box' that exists behind the plane), the re-recording has to use very reduced informational parameters. The two dimensionality of the plane and its resulting visual tensions are too well understood to need comment but the planar solution requires, like a photograph, the choice of one and only one view point (if we discount technical cubistic devices). From the placing of this frozen image comes a wish to be more precise about exactly *where* the thing is hanging in space and so in some cases I made simple border, linear or planar devices that emphasise the shape of the pictorial space and at the same time connect up critical points on a square grid that controls all the drawings. Sometimes the mesh of the compositional grid and the mesh of the image meet in a not entirely satisfactory crossing point. This is because the physical movements of the meshes are more complex than, say, a simple right-angle linear crossing. In this case I have often had to accept one of two, or several, imperfect solutions. If there is a logical reason for the choice, I prefer it (it's always better to work from a framework of criteria than have to make a series of decisions without precise indications or where the values seem even handed. In the latter cases one solution usually looks better and that decides it).

The predominant use of line rather than plane is because of its effectiveness as a tool of precision and at the same time its flexibility in defining a plane. The use of the unbroken line in five of the six themes shown in the exhibition, either open ended or forming a loop, came out of the way the original structures were conceived. For this I took an elastic thread and with it connected two transparent parallel planes that had been pierced with holes at the intersections of a regular square grid. The first of these were made in 1967 and it has remained of continuing interest right up to works done in 1975/76 which use a Peano space filling curve where the continuous line comes full circle and it is no longer an edge but a plane in itself.

Gillian Wise Ciobotaru

Opening Movement 1976 paint on paper 60×60cm

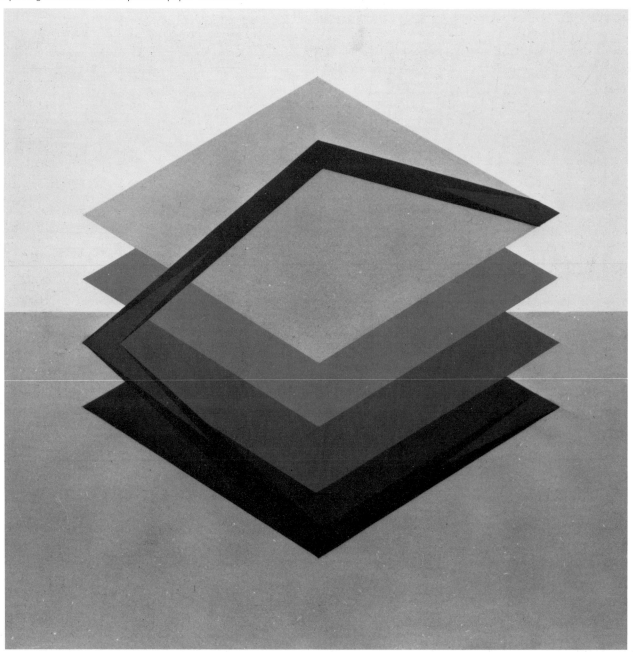

Winged Net, Shadow Trace, Yellow and Blue 1976 paint and ink on paper 60×60cm

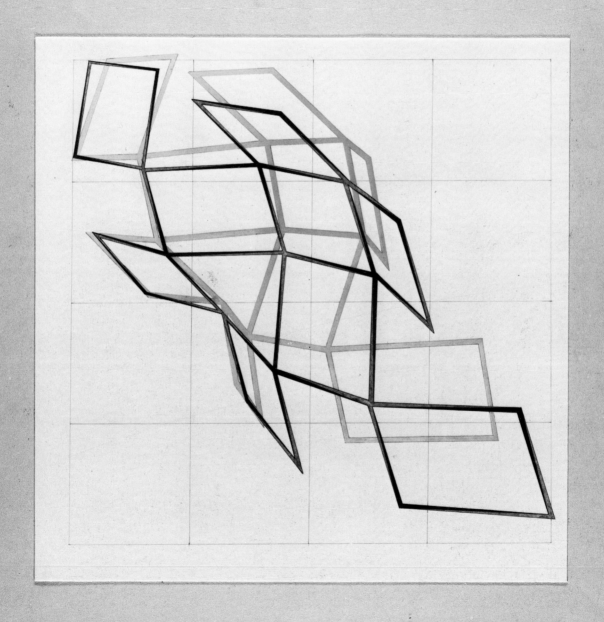

Norman Dilworth

I made this work at an international symposium at Antwerp in 1976. The object results from the path of a line drawn through a grid. A line which has a physical dimension following a predetermined route can generate a three-dimensional form. The line chosen here, with these dimensions, generates this particular form.

One man exhibition, Galerie Magazijn, Groningen, 1978

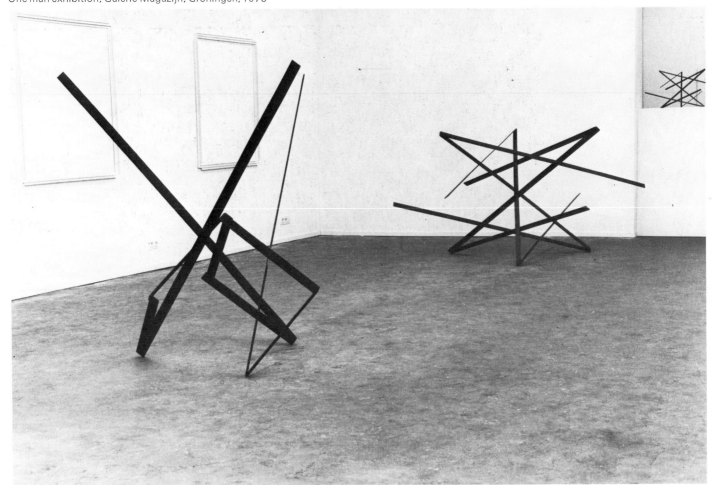

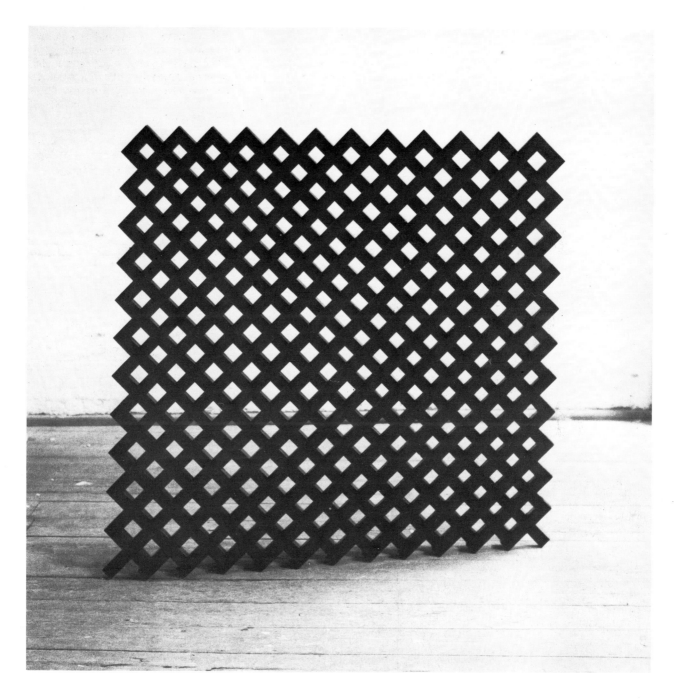

Norman Dilworth

1933 Born in Wigan. 1971 Won competition for sculpture for Haverfordwest. 1974 Won competition for water sculpture, Crown Offices Cardiff. Work completed 1976. Lives and works in London and Amsterdam.

Exhibitions include:

1966 *Structure '66*, Cardiff. *Experiments in Form*, Grosvenor Gallery, London. *Constructions*, Axiom Gallery, London. 1967 Expo '67, Montreal. 1968 Redmark Gallery, London. 1970 Galerie Nouvelles Images, The Hague. 1972 *Four artists*, Galerie Nouvelles Images, The Hague. 1973 Lucy Milton Gallery, London. *Four English Systematic Artists*, Galerie Swart, Amsterdam. *Systems 11*, Polytechnic of Central London. 1974 *British Painting '74*, Hayward Gallery, London. *British Sculptors Drawings'*, Sunderland. 1975 Galerie Lydia Megert, Bern. Galerie Pa Szepan, Gelsenkirchen. Lucy Milton Gallery, London. *From Britain '75*, Helsinki. *Drawings*, Galerie Lydia Megert, Bern. *Dilworth, Kidner, Steele*, Galerie Jacomo-Santiveri, Paris. *Englische Konstruktivisten*, Stadtische Kunstsammlung, Gelsenkirchen. *Five Systematic Artists*, Welsh Arts Council Tour. *Rationale Konzepta '75*, Gelsenkirchen. 1976 Galerie Swart, Amsterdam. *Rational Concepts, English Drawings*, Kunstcentrum 'Badhuis' Gorinchem and Museum Nijmegen, Holland. 1977 Galerie Lydia Megert, Bern. Galerie Swart, Amsterdam. *Three Artists*, AIR Gallery, London. Antwerp Symposium, Stedelijk Museum, Schiedam. *Dilworth, Hughes, Lowe, Steele*, Annely Juda Fine Art, London. 1978 *Drawings for Sculpture*, Muller-Roth, Stuttgart.

One man exhibition at Galerie Swart, Amsterdam. 1977.

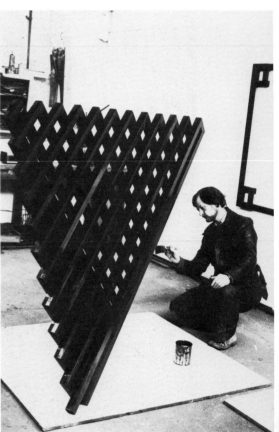

John Ernest

Relief Painting: Iconic Group Table 1977 89.5 × 89.5 × 8cm gouache on wood structure

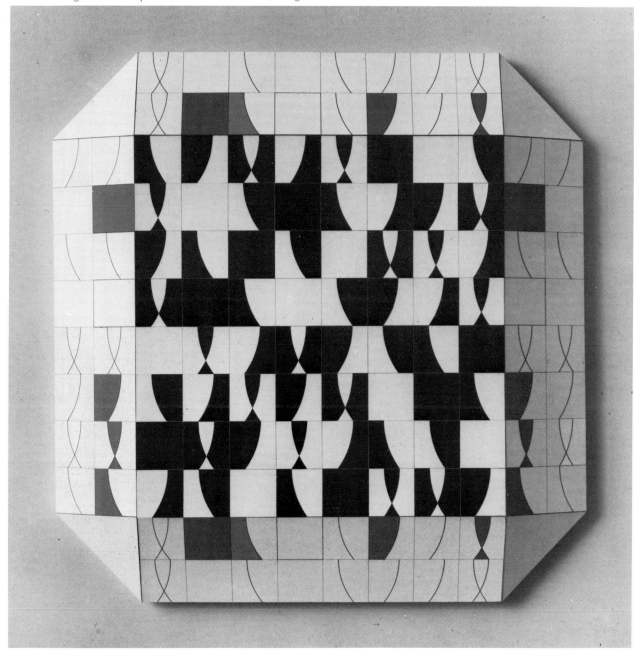

John Ernest

Groups are mathematical structures with a wide range of applications both in mathematics and in phenomena of the physical world. A group may pinpoint an unknown elementary particle, describe the symmetries of a Platonic solid or explain the underlying structure of marriage laws in a primitive society.

We may think of a group as being composed of a number of elements (the number is the order of the group), together with a rule for combining pairs of elements. The result of such a combination must itself be a member of the group. Suppose that the numbers 2 and 3 are such elements and that multiplication is the rule of combination, then 2 x 3 gives as its product the number 6 which must also be an element of the group. The number 1 plays a special role in a multiplication system : If we multiply any number by 1 (or 1 by any number), that number remains unchanged. Every group has a special element called the *Identity* element which behaves in exactly this way. If instead of multiplication we were to take addition as the operation (rule of combination), the identity element would be the number 0, since $2 + 0$ or $0 + 2 = 2$.

A group can be shown in the form of a table. If we set out its elements at the head of rows and columns we can then find any product just as we would in a multiplication table. In a sense this gives a formalised picture of a group, though the signs for the elements are arbitrary ones. A table for a particular group – sometimes known as the Klein group – is shown in figure 1. It is of order 4, the elements being I (identity), A, B, and AB. When we examine its products we can see that the group operation is not that of multiplication. Each element has a kind of off-on effect upon itself, like the operation of an electric switch which closes an open circuit or opens a closed one. For example ; $A \cdot A = I$ but $A \cdot A \cdot A = A$ since this is equivalent to $A \cdot (A \cdot A) = A \cdot (I) = A$.

To construct an iconic table for a group the arbitrary signs for the elements must be replaced by images which respond to the operation in a visually comprehensible manner. The rule of combination must be given an 'appearance'. A good clue as to how to go about it for this group is provided by the off-on duality of the operation.

Consider that the squares of the table are composed of black and white figures and that the act of combining consists of placing one square on another. When a white area falls on a white area it remains white : Black on white or white on black become black : Black on black becomes white. Written more compactly ; $W \cdot W = W$, $W \cdot B = B$, $B \cdot W = B$, $B \cdot B = W$.

In fact the rule given by this set of instructions is a familiar one in arithmetic. If we replace each W by $+ 1$, and each B by $- 1$, we find that it is none other than the rule for the multiplication of signs, and is in itself an order 2 group. (fig. 2).

The rule together with a few design decisions allows us to construct an iconic table. The first requirement is an all white square for the identity element, for by our rule such a square will leave the appearance of any other unchanged. The first ordinary element – call it A – can simply be an all black square. These 2 elements, I and A, 'close' to form a group identical with the $(+ 1, - 1)$ group. To enlarge the group we must introduce a new shape. One way to do this is to divide the square along a diagonal into half white and half black. This new shape will generate 2 elements which we will call B and AB, making a group of order 4, in fact the Klein group. (fig. 3).

We can say of this group that it has 2 generators, A and B, for excluding the I element, the number of generators of a group is the least number of elements from which the whole group could be constructed. We would have arrived at the same group with a different pair of generators had we selected the shapes in a different order. For example ; A and AB could exchange roles so that either could combine with B to generate the other.

The groups illustrated belong to a particular family. They share the characteristic that the order of any member group is given by the expression 2^n, where n is the number of generators. To represent the member in which $n = 3$, an order 8 group, we need merely chose the other diagonal to generate the 4 new elements. (fig. 4). This process can be carried on for any value of n, for it is not necessary to restrict the choice to diagonals. Any division of a square into 2 parts (not necessarily equal) will act as a generator in this representation.

	I	A	B	AB
I	I	A	B	AB
A	A	I	AB	B
B	B	AB	I	A
AB	AB	B	A	I

Fig. 1

Fig. 2

	+1	−1
+1	+1	−1
−1	−1	+1

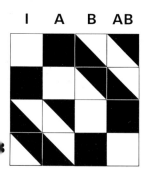

I A B AB

The visual structure of the relief painting should now be self-evident. It is an order 8 group table in which there are some refinements. The sequence of elements heading the rows is not the same as the sequence heading the columns. (Even in a multiplication table this would not be a requirement, only a convenience). The elements are arranged as repeated motifs in two broad bands which intersect — transforming themselves square by square — in the table proper. The visual information by which they can be recognised is reduced in two stages as they move out from the table, but is sufficient in the row (or column) adjacent to the table for them to be identified.

John Ernest

1922 Born in Philadelphia. 1946 Lived and painted in Sweden and France. 1951 Moved to London. 1952-56 Studied sculpture at St. Martin's School of Art and made constructions exclusively thereafter. Has taught at Bath Academy of Art, Corsham. Now teaching at Chelsea School of Art.
Exhibitions include:
1964 Institute of Contemporary Arts, London. Queens University, Belfast. 1967 *Unit, Series, Progression*, Arts Council. *Constructions*, Arts Council (touring exhibition). 1968 Documenta 4, Kassel. *Relief/Construction/Relief*, Museum of Contemporary Art, Chicago. 1971 *Four artists: Reliefs, Constructions and Drawings*, Victoria and Albert Museum London.
Matrix, Arnolfini Gallery, Bristol. 1972 Systems, Whitechapel Art Gallery, London (touring exhibition).

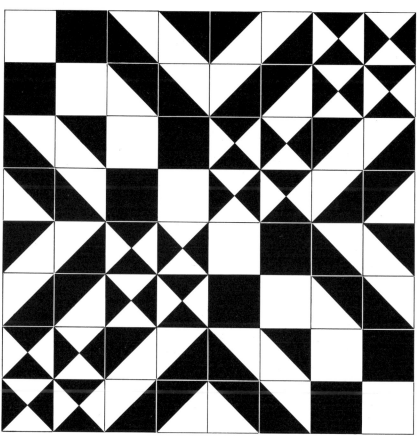

Anthony Hill

Linear Construction B Large Red 1972 engraved laminated plastic 61 × 61cm

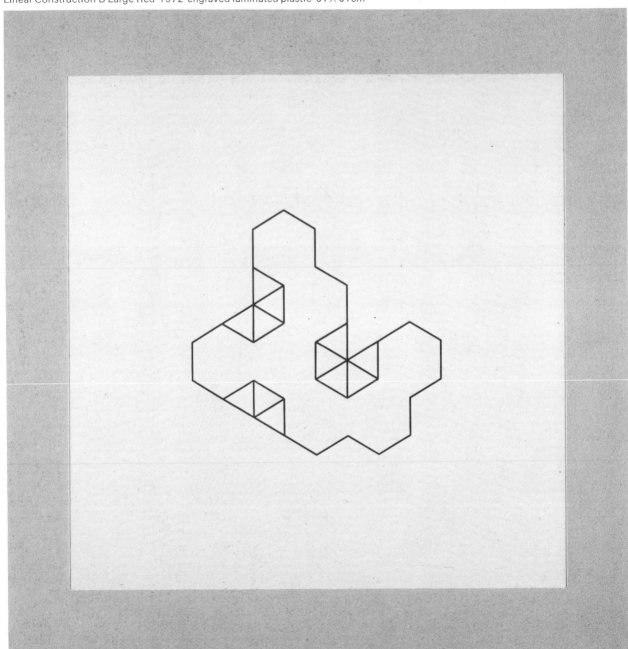

The Nine — Hommage a Khlebnikov No. 1 1975 relief laminated and engraved plastic 86.3×86.3cm

Anthony Hill

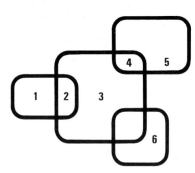

In the scheme, the areas 1 and 5 represent those of ART and MATHEMATICS respectively; and 3 that of a *cross-domain* which I call the PHENOMENOLOGY OF STRUCTURE.[1]

Distances and sizes can be ignored so as to make a simple point about *one way art and mathematics can be related.*

The fourth area 6 can stand in for a choice of sciences — or any one science in particular — completing the scheme which also offers in part a heuristic definition of 3 .

At a more playful level it also allows me to explain how most of my activity at present, traversing 1 to 5 , finds me more often in the overlap areas 2 and 4 .

My involvement in a more definite approach or programme ?
There are times when casuistics get lost and times when they need refurbishing.[2]

[1] Apart from the two articles of mine cited by Bann in the introduction, see also the following:
'The Structural Syndrome in Constructive Art' in 'MODULE, PROPORTION, SYMMETRY, RHYTHM' Ed. G. Kepes, Braziller, N.Y. 1966
'Programme. Paragram. Structure' in DATA, Directions in Art, Theory and Aesthetics, Faber & Faber, 1968
'Art and Mathesis-Mondrian's Structures' LEONARDO (Vol. 1. No. 3) 1968. The ideas in this piece were later to emerge as a joint research with Frieder Nake, see his chapter 'Mondrian Strukturel-Topologische' in 'ASTHETIK ALS INFORMATIONS VERARBEITUNG' Springer-Verlag, Wien, New York, 1974.
'A View of Non-Figurative Art and Mathematics — and an Analysis of a Structural Relief'. In this piece, published in LEONARDO Vol. 10, No. 1, 1977, some account is given for the ideas employed in the three reliefs entitled 'The Nine — Hommage a Khlebnikov,' the first of which is in the present showing.
[2] See my article 'Desiderata (1971)' Studio International, May 1972.

1930 Born in London. 1947-51 Studied at St. Martin's and Central Schools. 1950-54 Made abstract paintings and collages for serial production. 1958-75 Worked on combinatorial problems. 1971 Awarded a Leverhulme Research Fellowship to work as Honorary Research Fellow in the Mathematics Department of the University College, London. (1971-72)

Exhibitions include:

1950 *Aspects of British Art*, ICA. 1952 Salon des Realites Nouvelles, Paris. 1954 *Artist v. machine*, London. 1955 *Nine Abstract Artists*, Redfern Gallery. 1956 *This is Tomorrow*, Whitechapel Art Gallery. 1958 ICA. 1960 *Konkrete Kunst*, Helmhaus, Zurich. 1961 *Art Abstrait Constructive*, Denise Rene Gallery, Paris. 1961 Paris Biennale. 1962 *British Constructivist Art*, ICA. 1962 *Constructivisme*, Galerie Dautzenberg, Paris. 1962 *Experiment in Construction*, Stedelijk Museum, Amsterdam. 1962 *Konstruktivisten*, Leverkusen Museum. 1963 ICA. 1965 *Art and Movement*, Tel Aviv Museum. 1966 Kasmin Gallery. 1968 *Relief/Construction/Relief*, Museum of Contemporary Art, Chicago. 1968 *Plus by Minus: Today's half century*, Albright-Knox Art Gallery, New York. 1969 Kasmin Gallery. 1969 *Constructivism: Elements and Principles*, 1st Nurnberg Biennale. 1969 10th Middelheim Biennale. 1974 *British Painting '74*, Hayward Gallery. 1975 University of East Anglia, Constructivist Collection — MOMA Oxford. 1976 Arte Inglese Oggi, Palazzo Reale, Milan. 1977 Hayward Annual, Hayward Gallery, London. 1978 *British Painting 52-77*, Royal Academy, London.

Malcolm Hughes

1920 Born in Manchester. Studied at Regional College of Art, Manchester and at Royal College of Art, London. At present Reader in Fine Art, The School of Postgraduate Studies, Slade School of Fine Art, University College, London.

Exhibitions include:

1965 Institute of Contemporary Arts, London. 1967 Axiom Gallery, London. Constructions, Arts Council (touring exhibition). 1969 System, Amos Anderson Museum, Helsinki. 1971 *Four artists: Reliefs, Constructions and Drawings*, Victoria and Albert Museum, London. *Matrix*, Arnolfini Gallery, Bristol. 1972 Lucy Milton Gallery, London. *Systems*, Whitechapel Gallery, London (touring exhibition). 1973 *I Paint a Painting, England 1973*, Studio La Citta Galleria d'Arte, Verona. 1973-74 Touring Exhibition (arranged by Lucy Milton) : Hull, Manchester, Portsmouth, Southampton, Leicester and Sheffield. 1974 *Basically White*, ICA London. *Art as Thought Process*, Arts Council, Serpentine Gallery, London. 1975 *New Work 2*, Arts Council, Hayward Gallery, London. *Rational Concepts, English Drawings*, Kunstcentrum *Badhuis* Gorinchem and Museum Nijmegen, Holland. 1976 *Arte Inglese Oggi*, Milan, Italy. *Panorama Quattro*, Galleria la Polena, Genova, Italy. *X1 Biennale Internationale d'Art*, Menton, France. *Sculpture for the Blind*, The Tate Gallery, London. 1977 *British Artists of the Sixties*, The Tate Gallery, London. *Dilworth, Hughes, Lowe, Steele*, Annely Juda Fine Art, London. *Rationale Konzepte, 7 Englische Kunstler*, Galeria Lydia Megert, Bern. Second Symposium I.F.K.G., Varese, Italy. *British Painting 1952-1977*, Royal Academy of Arts, London.

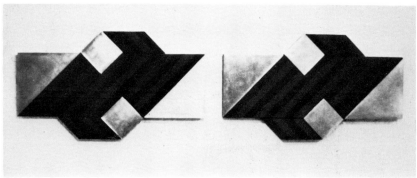

Fig. 1

Over a number of years I have been concerned with the use and development of juxtaposition. When two or more elements are brought together external (fig 1) and internal (figs 2,3) dialogues may emerge :

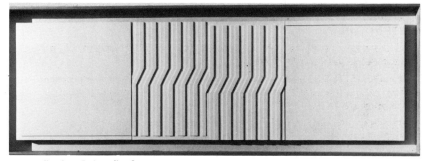

Above fig. 2 Below fig. 3

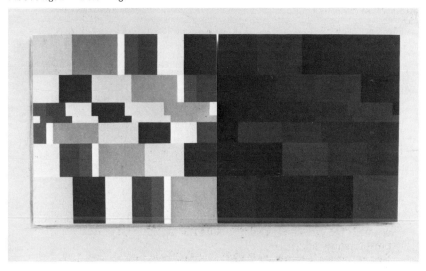

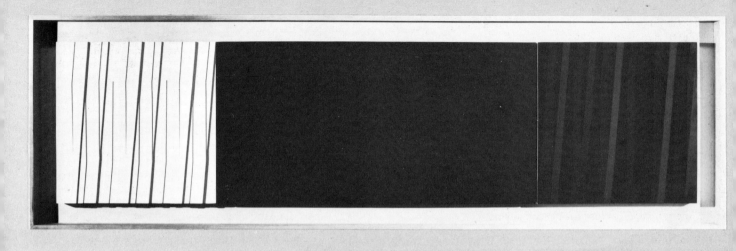

fig. 4 Three unit relief/painting 1973 mixed media 58.6 x 243.8 cm

'By working with a single conceptual structure and developing it in alternative or parallel modes and then critically examining what can be induced through juxtaposition and cross reference this rational based process can reveal new extended and unexpected properties. These seem to point the way to a relatively unexplored intuitive creative area *beyond* the rational, where unexpected linkages are sensed and responded to by the mind via the senses. It is this potential for bringing about extended non-centred realities that the use of juxtaposition and induction seem to possess. It becomes an attempt to reveal reality by the use of the context rather than the core.' (Extract from a statement for the exhibition 'New Work No. 2', Hayward Gallery Dec 1975-Jan 1976, which included the work in this exhibition.)

fig. 5

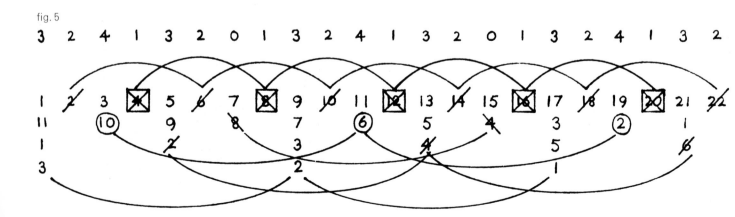

Malcolm Hughes

The work in this exhibition : '3 Unit Relief/Painting'
1973 (fig 4) was the outcome of :
(a) working with numerical information arrived at by
 successively 'shredding' the natural number
 sequence 1 – 22 (fig 5) ;
(b) transforming this basic information, via drawing
 (fig 6), so that two different manifestations
 (relief/painting) became possible ;
(c) combining these two square units, together with
 a third double square unit which carries no
 ordered information.

At the perceptual level the work uses spacial
disjunction. That is, the reading and decoding of the
conceptual content takes place by means of a
visual imprint carried across the neutral space.

This concern is not unlike the use of space/silence in
the later music of Webern. There are also other
aspects of his music that interest me :
'Webern was the first composer for whom the basic
series was more than a row of notes in one
dimension : he did not even adapt the series to a
three-dimensional world of sound, but rather
created "space". By telescoping a series that was
originally in one plane, and split up into fragments
(motives) he achieved an interwoven structure like a
relief, firmly held up by acoustic material : the full
significance of this type of material construction, and
of this method of effecting connections, has only
latterly been appreciated.' *The Composer's
Freedom of Choice* Herbert Eimert. die Reihe 1957.

Malcolm Hughes

fig. 6

Michael Kidner

1917 Born in Kettering, Northamptonshire. 1967 Artist in Residence, University of Sussex. 1968 Artist in Residence American University, Washington D.C. Now teaching at Bath Academy of Art, Corsham.

Exhibitions include:

1959 St. Hilda's College, Oxford. 1962-64 Grabowski Gallery, London. 1963 John Moores, Liverpool (prizewinner). 1965 *The Responsive Eye*, Museum of Modern Art, New York. 1967 Axiom Gallery, London. University of Sussex, Brighton. Arnolfini Gallery, Bristol. *Four British Painters*, Betty Parsons Gallery, New York. *Recent British Painting*, Tate Gallery, London. 1968 The Henry Gallery, Washington. 1969 Arts Council of Northern Ireland, Ulster Museum, (prizewinner) Belfast. *System*, Amos Anderson Museum, Helsinki. 1971 *Matrix*, Arnolfini Gallery, Bristol. 1972-73 *Systems*, Whitechapel Art Gallery, London (touring exhibition). 1973 *Constructive Art*, Leicester City Art Gallery. *Systems Activity*, Polytechnic of Central London. 1973 *Systems II*, Polytechnic of Central London. 1974 *British Painting '74*, Hayward Gallery, London. *Critics Choice*. Tooth Gallery, London. 1974 Lucy Milton Gallery, London, 1975 Jacomo-Santiveri Gallery, Paris. 1975 Recent British Painting, Grenoble, France. 1976 *Rational Concepts*, Gorinchem, Holland. *Colour*, Southern Arts Touring exhibition. 1977 *British Painting 1952–1977*, Royal Academy of Arts, London.

Unity and diversity. The drawing above is constructed on a square lattice, the points of which are one wave length apart. The units obtained duplicate each other. By reducing the distance between the lattice points to an irrational fraction of the wave length the units obtained become infinitely different. The drawing on the right is nearly, but not quite symmetrical, a feature which will continue to display itself as the drawing extends.

The painting included in the exhibition was generated by a similar lattice of wavy lines, but in this case the lines were arranged either parallel or opposite to each other (in or out of phase) and the shapes obtained had sides which were either parallel or opposite or a combination of both. By grouping the shapes according to their type, and ascribing a different size of rectangle to each type, a clearer visual pattern was achieved.

Yes, pattern. Pattern motivates the work — pattern as a way of understanding my relationship to the environment I live in. Ideally, I want a pattern which I can occupy, as much as Renaissance painters made space in their paintings which they could occupy. My relationship with the environment is different from that of the Renaissance. I feel an affective part of a secular world and no longer a passive spectator. I have to find my place in a world viewed as an Ecology.

Working drawings
for reliefs 1974

$\sqrt{5}$

Michael Kidner

Analysis of a Wave Pattern 1973 aquatec paint on cotton duck stretched over hardboard 91.5×91.5cm

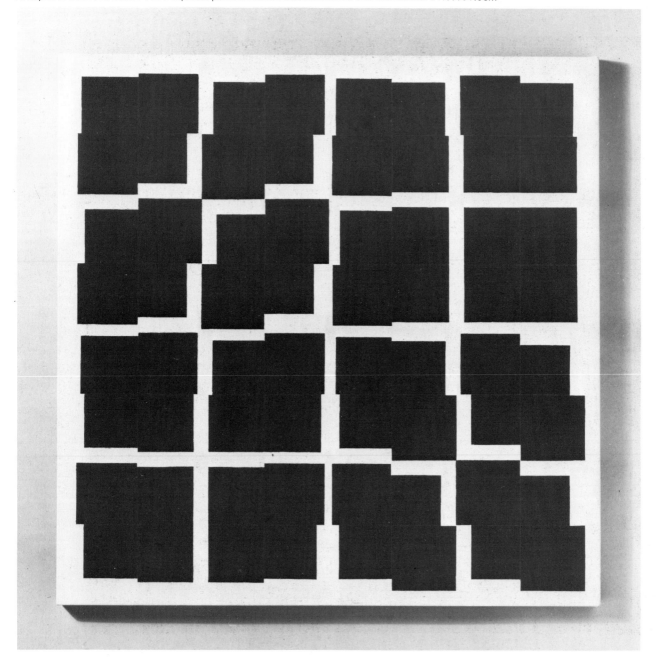

Tony Longson

CRS 1976 milled perspex, cellulose paint 60×60×10cm

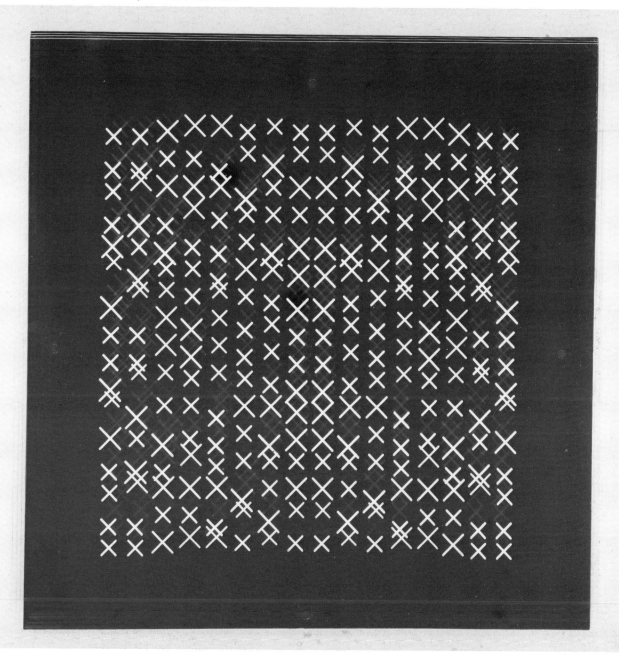

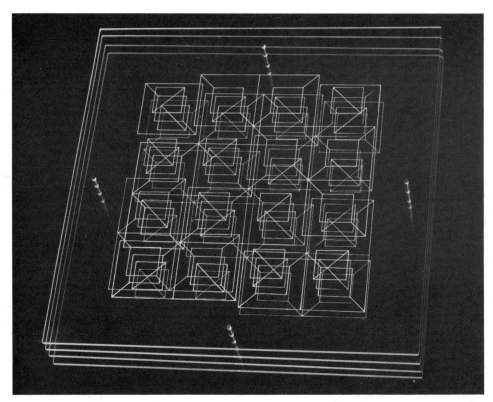

Group Theory Grid 1969
silkscreen on perspex

CRS is one of a group of constructions I made during the period 1974-77 with the use of computers. Ten years previously, I had started to make work from the background of two fundamental ideas introduced to me by Terry Pope while I was a student at Reading University. The first was that an interest in sight, and particularly the mechanisms which direct our understanding of space, could be the focus for creativity. The second was that research of this kind would demand appropriate resources, both in materials and techniques, which might change with each new investigation. *Group Theory Grid* was one of my first constructions, and as the name implies, the arrangement of the four elements originates in another discipline, plane geometry. However, it was the visual identity of the object in space which concerned me, and (to my surprise) this identity was more interesting than the separate components might have suggested. Together these ideas have formed the basis for my activity.

In 1974, under an Arts Council/Hatfield Polytechnic Fellowship, I had the chance to start using computers in my work full-time. Whereas I realised that they are able to handle complex information accurately, and this seemed to suit the demands of my work ; the thing that first impressed me about computers was their ability to draw, or display linear three-dimensional images. By accident I found that in the absence of clues to depth, these drawings would sometimes look flat ; and with this in mind. invented geometries which could be displayed on the screen and rotated in space through certain positions where they appeared to switch from two to three dimensions, and back again.

Becoming more familiar with the machinery and the way it is programmed, I realised that the relationship between ideas and their organization into material form was similar to my own approach to problems. Furthermore, the technology was capable of a generative contribution. Programming languages for example encourage certain structure (iterative

or repetitive steps, qualitative or quantitative values, conditional states etc.) which can have a direct equivalent in the description of visual questions. Similarly, the computer controlled drawing devices and milling machines used to make *CRS,* exhibit their own formal preferences, such as linearity, layering, repetition and symmetry. And at best, these characteristics can have a clear visual presence in the work.

CRS and four related constructions came out of the two to three dimensional transformations I have described. I became more interested in the possibility of making versions of these drawings in space, where the experience might be real rather than implied (like Borromini's perspective arcade in Rome) ; and the technology itself suggested a way that this might be achieved. As the computer has a set of information about my drawing, which it was organising in such a way as to display it on a screen, I was able to reorganise that information to be displayed on four imaginary screens, one behind the other, which could correspond in the construction to four transparent layers of acrylic, each one to have its share of the original drawing.

In *CRS* that drawing is comparatively simple ; a regular square matrix, with each point located on just one of the four planes by a cross. Despite its simplicity, this structure acts as a carrier for other orders of sense, such as perspective, pattern recognition and symmetry ; many of which I enjoy most when they seem to occupy the visual threshold between accident and intention.

1948 Born in Stockport. 1967-71 Studied at Reading University, Fine Art Department. 1971-72 Dutch Government Scholarship. 1972-74 Research in Fine Art, Newcastle-upon-Tyne Polytechnic. 1974 Research in Art and Computers, Hatfield Polytechnic. Guest Research, National Physical Laboratories. Now teaches as session lecturer for Reading University and is a visiting lecturer at the Slade and Wimbledon Colleges of Art.

Exhibitions include:
1972 *Eight Space Constructions,* The Hague.
1973 *Themes and Variations,* Wolverhampton City Art Gallery. *Aerial Structures,* Sunderland Arts Centre.
1974 *Peter Stuyvesant Northern Painters and Sculptors* (prizewinner). 1975 *Attitudes to Drawing,* Arts Council travelling exhibition. 1976 *Art and Environment,* Lancaster University. 1976 *Space Drawing,* Hatfield Polytechnic. *Space* (Longson, Moreland, Pope), Abbot Hall Gallery, Kendal.
Book : *Art with Computers* – Ed. Ruth Leavitt USA 1977 *Visual Objectives,* Harlow. *Computer Art,* Waterloo, Ontario, Canada. 1978 *Constructive Rationale* Polytechnic of Central London.

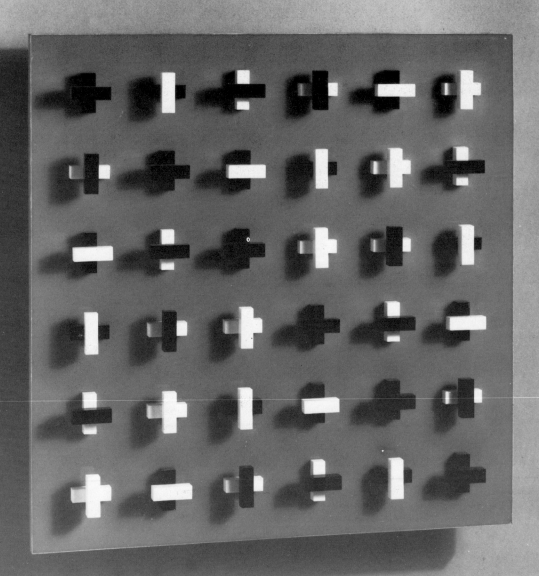

Peter Lowe

System of Six Elements on Grey
1969 perspex and wood
49×49cm

1	2	3	4	5	6
4	1	5	2	6	3
5	3	1	6	4	2
2	4	6	1	3	5
3	6	2	5	1	4
6	5	4	3	2	1

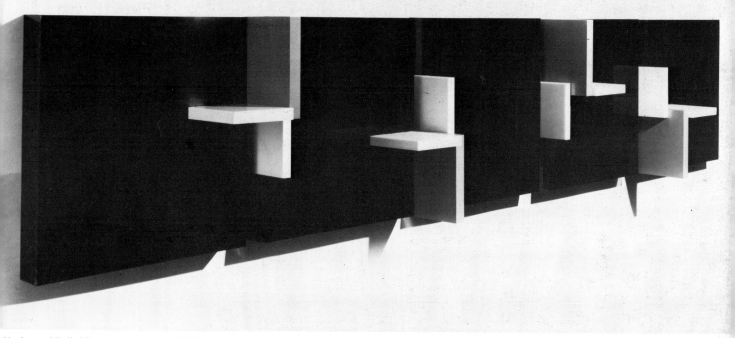

Horizontal Relief Construction No. 2 1969 perspex 41 × 224cm

Notes on Horizontal Relief Construction No. 2 1969.
Horizontal Relief Construction no 2, is typical of a group of works I began in the mid 1960's and reflects my interest in proportion. All dimensions including the thickness of the elements are governed by a set of interelated measurements. The position of the large black elements remains constant while the white and the grey elements change position according to a simple implied rule.

While it is easy to see many interrelated patterns of symmetry in 'Six Elements on Grey', these do not clearly reveal the basis of the construction and a few words of explanation are probably needed. This work is based on a permutation and owes much to the discoveries of my teachers Kenneth and Mary Martin. The type of permutation I have used here however differs from the "pendulum" permutation used by the Martins.* It is based on a different principle and has different characteristics. The elements in the permutation are represented in the actual construction by six possible types of cross using not more than two colours. For example, there is a black horizontal over a black vertical,

a white vertical over a black horizontal, a black horizontal over a white vertical etc. The permutation itself is constructed as follows ; figures 1 - 6 are arranged consecutively in the first row. In the second row and each subsequent row each figure is moved to the right a certain number of places according to its value. Thus one moves one place, two moves two places and so on until one and six have exchanged places with one another. It is assumed that there is also an empty column corresponding to zero which is counted as one space. Numbers which would otherwise move beyond column six are counted again from the left.

Michael Compton, Analysis of Selected Works, Kenneth Martin, Tate Gallery 1975.

Peter Lowe

Working drawings for reliefs 1974

1938 Born in London. Studied under Kenneth and Mary Martin at Goldsmiths College, School of Art, London.

Exhibitions include:

1963 *Six English Painters*, Drian Gallery, London. Drian Artists, Drian Gallery, London. *The Geometric Environment*, AIA Gallery, London. *Construction England*, Arts Council (touring exhibition). *Plus and Minus Inventions* (with Colin Jones), AIA Gallery, London. 1966 *Constructions*, Axiom Gallery, London. *Relief Structure*, ICA, London. 1967 *Unit, Series, Progression*, Arts Council (touring exhibition). 1968 Cinetisme-Spectacle-Environment, Maison de la Culture, Grenoble. Constructions, Greenwich Theatre Gallery. Constructions from The Arts Council Collection, Arts Council (touring exhibition). 1969 *System*, Amos Anderson Museum, Helsinki. 1970 *Space Dimensions*, De Zonnehof, Amersfoort Museum van Stad en Land, Groningen. Stedelijk Museum, Schiedman. 1971 *Matrix*, Arnolfini Gallery, Bristol. *Matrix*, Welsh Arts Council Gallery. 1972 *Systems – Drawings*, *Reliefs*, Lucy Milton Gallery, London. *Systems*, Whitechapel Gallery, London (touring exhition). Salon des Realities, Nouvelles, Paris. Galerie Nouvelles images, The Hague. *Constructive Art*, Leicester Museum and Art Gallery. 1973 *Systems 11*, Polytechnic of Central London. 1974 Gardner Centre, University of Sussex. Lucy Milton Gallery, London. *Basically White*, ICA, London. Kultuurcentrum de Warende, Tournhout, Belgium. Kultuurcentrum, Hasselt, Belgium, Kultuurcentrum Waregem, Belgium. Dixieme Biennale International de Menton, France. *Industrial Sponsors*, London. *British Painting '74* Hayward Gallery, London. Museum der Stadt, Gladbeck. IAFKG Conference, *Badhuis*, Gorinchem, Holland. 1975 Sequenzen Zwischen Weiss und Schwarz, Museum der Stadt Gelsenkirchen. *Ways of Making*, Welsh Arts Council (touring exhibition). *Rationale Konzepte '75*, Galerie Pa Szepan, Gelsenkirchen. Galleria Primo Piano, Rome. 1976 *Plus Minus*, Southampton Art Gallery. Gardner Arts Centre, University of Sussex. *Arte Inglese Oggi 1960–76*, Palazzo Reale, Milan. *Rational Concepts, English Drawings*, Kunstcentrum *Badhuis*, Gorinchem and Museum Nijmegen, Holland. *English and Dutch Rational Drawings*, De Volle Maan, Delft. *Systemes et Series*, Musee des Beaux Arts, Besancon, France, 1977 AIR Gallery, London. Stedelijk Museum, Schiedam. *Dilworth, Hughes, Lowe, Steele*, Annely Juda Fine Art, London.

1905 Born in Sheffield. 1921-23 and 1927-29 Studied at Sheffield School of Art.
1923-29 Worked in Sheffield as a designer.
1929-32 Studied at the Royal College of Art.
1946-67 Visiting Teacher Goldsmiths College School of Art. 1971 Awarded the OBE.

Exhibitions include:

1968 Documenta 4, Kassel. *From Constructivism to Kinetic Art*, London Arts, Detroit. *Art and the Machine*, University of East Anglia, Norwich. 1969 *Konstruktive Kunst: Elemente und Prinzipien*, Nuremberg, Biennale. 1970 Waddington Galleries. *Kinetics*, Haywards Gallery, London. *Multiples by Unlimited*, Arnolfini Gallery, Bristol. 1970-71 Arts Council tour of Great Britain (with Mary Martin). 1972 *Non-Objective World*, Annely Juda Gallery, London, also Basle, Milan, Texas. 1973 *Henry Moore to Gilbert and George*, Europalia, Brussels. 1974 Waddington Galleries. Galeria Swart, Amsterdam. *Recent British Painting*, Rothmans Foundation, tour of France. *Basically White*, ICA London. *Critics Choice 1974*, Arthur Tooth and Sons Ltd., London. *British Painting 1974*, Hayward Gallery, London. *Aspects of Abstract Painting in Britain*, Edinburgh Festival and Brussels. 1974-75 *Art as Thought Process*, Serpentine Gallery, London. 1975 *Internationale Kleinformat-Ausstellung*, Galeria Lydia Megert, Bern. 1975 Tate Gallery Retrospective. 1976 Scottish National Gallery of Modern Art (with Henry Moore). 1976 *Recent British Art*, British Council exhibition touring Europe. 1977 *A Silver Jubilee exhibition of Contemporary British Sculpture 1977*, Battersea Park, London. 1977 *Hayward Annual*, Hayward Gallery, London.

Extract from an article 'Chance and Order', p. 46, in the Tate Gallery catalogue of Kenneth Martin's exhibition in 1975. This article was originally published in *One*, October 1973.

... The pleasures of relating one concept to another and seeing what will happen through their fusing together can be very great. One concept leads to another and it can be exciting to put together seemingly opposing ones, or ones in different categories. These things come about as one works, and one can be forever

Kenneth Martin

Facing page Chance, Order,
Change 2 (ultramarine blue)
1976 oil on canvas 91·4 x
91·4 cm
Right Study for Chance,
Order, Change 2 (ultramarine
blue) 1976 pencil and ink
26 x 34·5 cm

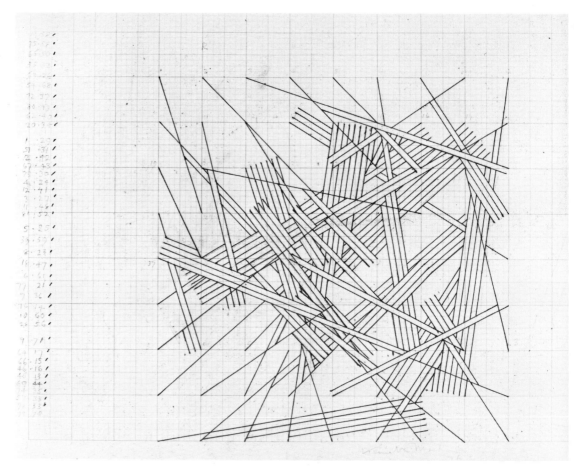

expanding, limiting and expanding again these
processes of invention . . .
Recently I have made works which combine
chance and programming in the time sequence of
activity. The drawings and their resulting paintings
and prints I have called *Chance and order.* Not only
does chance define position, it gives sequence also.
The points of intersection on a grid of squares are
numbered and the numbers are written on small
cards and then picked at random. A line is made
between each successive pair of numbers as they
are picked out. In early drawings, to show and use
the fact that each direction was drawn in sequence,
a system of parallel lines was invented. They were
always on the same side of the direction throughout
a work. Chance determined the sequence and also
the number of parallel lines to each. 1 line would
serve for the first drawn, 2 for the second, 3 for the
third and so on. Each block of lines and spaces was
drawn underneath the preceding ones and did not
pass through them.
In a square grid each direction is diagonal, vertical
or horizontal to a part or whole of the grid. Each
drawing has a certain characteristic force.
Subsequently, varying the way a time sequence of
drawing the parallel lines was used, or changing the
nature of the grid, could yield a succession of
drawings of a variety of invention within the range of
one set of pairings. For instance a field of circles
would give to the lines of direction the character of
radii and chords. Also pairing itself could be
changed to other groupings of three or more
successive points.
Kenneth Martin

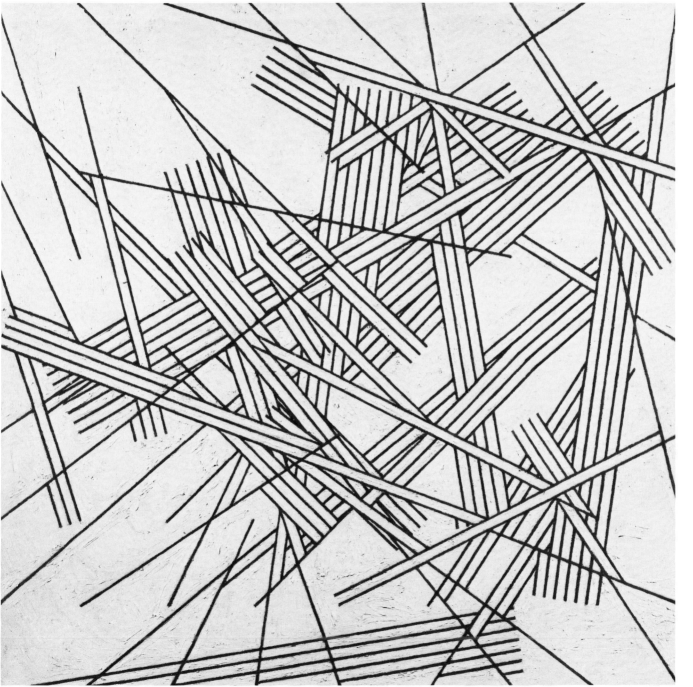

Terry Pope

All my constructions using large numbers of repetitive elements, in shapes easily recognised by the spectator, have at least two objectives. One is to modify the exact rules of perspective beyond the use of a single projection centre. This is essential in handling stereoscopic information, because formal perspective describes a vision which is both static and monocular. It does, within its limitations, allow certain spatial ambiguities, but these form quite a small repertoire.

In contrast, the other is a strategy to create, with binocular fusion, perceptual experiences of space and depth invisible through orthodox binocular functions. The diagram to the right explains how the repetitive elements can be visually reorganised in space by superimposing the images seen by each eye. Depending upon the convergence of vision, phantom elements are seen creating complex depth levels and gradients, either in front of or behind the surface of the object. The muscular convergence of the eyes involved in this activity, though subtle, is another mechanisam for stimulating or suppressing stereoscopic vision.

Normal vision is a vigorous and highly developed

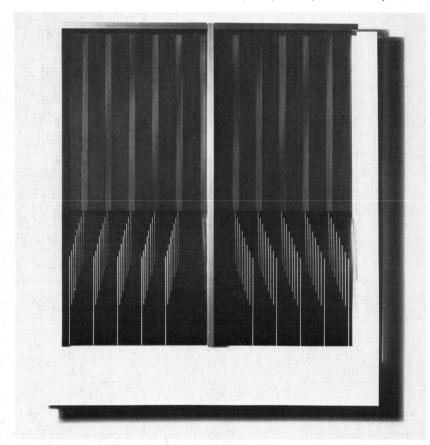

Linear Space Construction perspex and silkscreen process 91.4 x 91.4 x 15.2 cm

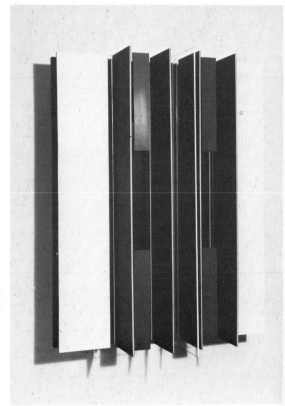

Overlap Construction 1964 perspex, melamine
76.2 x 45.8 x 20.3 cm

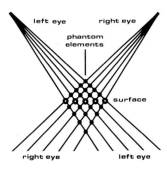

sense, creating an image which in many ways is in exceptional correspondence with reality. So pervasive have the modes become by which this is achieved, powerful stimuli are needed to deflect established visual functions into new roles. Not uncharacteristically, these functions themselves in their turn become rapidly established, irrespective of how unusual their stabilised forms may be.

Terry Pope

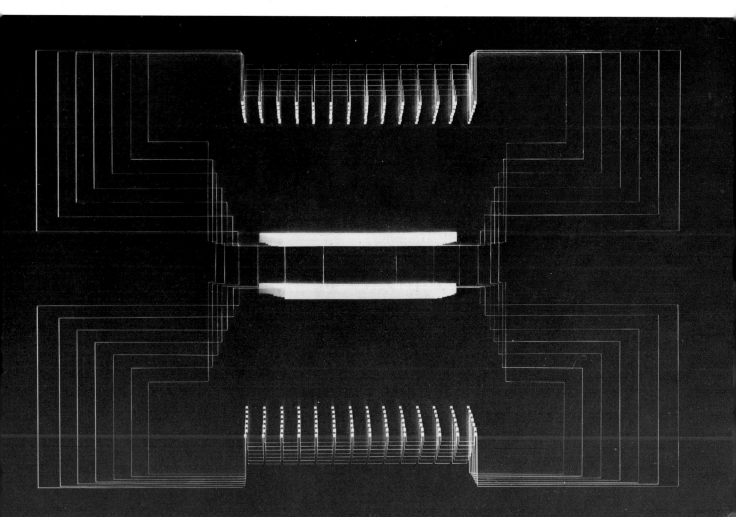

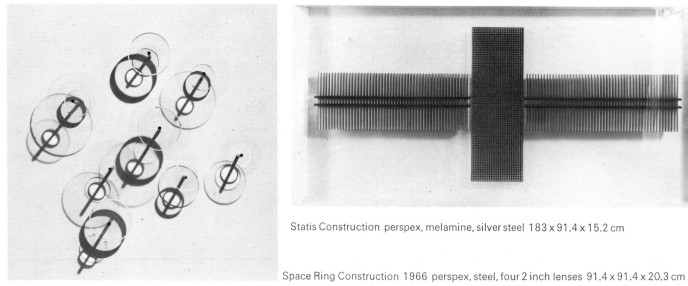

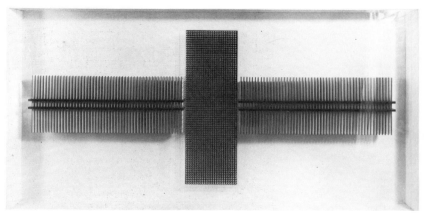

Statis Construction perspex, melamine, silver steel 183 x 91.4 x 15.2 cm

Space Ring Construction 1966 perspex, steel, four 2 inch lenses 91.4 x 91.4 x 20.3 cm

1941 Born in England. 1958 Began making constructions. 1959–62 Studied at Bath Academy of Art. 1962–63 Royal Netherlands Government Scholarship. Now teaches at Reading University, Chelsea School of Painting and the Slade Postgraduate School.

Exhibitions include :

1966 *Constructions*, Axiom Gallery, London. 1967 Constructions, Arts Council, *Unit-Series-Progression*. 1969 John Moores, Liverpool. Mutation Phenomena 2, Midland Group. 1973 Summer Show, Lucy Milton Gallery, London. Institute of Contemporary Arts, London. 1974 Arts Council Award. Space Constructions. Lucy Milton Gallery London, One Man Show. 1976 Arts Council Award. Space Abbot Hall Gallery, Kendal. (Longson, Morland, Pope). 1977 Visual Objectives, Harlow Playhouse. TELIC Constructionist Exhibition, Kansas City, USA. British Council Award. 1978 Constructive Rationale, PCL London. Information et Arts. UNESCO, Paris.

Publications

Perception and Construction. STRUCTURE Series 6–2, 1964.
Works in public collections including Cornwall Education Committee, Abbot Hall Museum, and private collections in Europe, England, and North America.

Keith Richardson-Jones

Born in Northampton. 1952 Left Royal Academy Schools. Lives and works in Tintern. Teaches at Newport College of Art. 1972 Began work on System/Serial; developing from earlier relief constructions and colour/structure paintings.

Exhibitions include:

1966 *Soundings Three*, Signals Gallery, London.
1967 *Survey '67*, Camden Art Centre, London.
1970 Lisson Gallery, London. *Three towards Infinity*, Whitechapel Gallery, London. John Moore's, Liverpool.
1971 Arts Council *Spectrum*. 1972 *Ten British Printmakers*, Lucy Milton Gallery, London.
1976 Galerie Nouvelles Images, Den Haag. Two-man show, Peterloo Gallery, Manchester. *New print acquisitions*, Tate Gallery, London. 1977 Arts Council Gallery, Cardiff. Kunst Grenzen, Multi-Art Points, Amsterdam.

Van Doesburg's term, 'the vocabulary of geometric form' will serve to define the language I employ within the general principles and basic tenets of constructive theory : a form language that provides me with a flexible framework for examination of the use of number systems in organising orders of forms within which other unpredictable relationships and dispositions of those same forms may occur.

The individual works are realised, here as paintings, to reveal these hidden orders, in asymetrical patternings, that I intuitively anticipate but cannot predict. Paradoxically, the imaginative and intuitive processes are liberated by the *predictability* of regular number sequences, which take wing when combined or opposed in functions outside of the mathematician's usage.

My work in this exhibition has as its basic structural premise, a dimensional progression in which a constant small difference is added at successive stages to produce a run of regular increases of interval. Arithmetic progressions are more useful for this than for instance the Fibonacci series as the added differences can be restricted to meet the need for small extensions. Gradual changes or transformations are effected, from small to larger, narrow to wider, rectangle to square ; to generate a gradual shift of movement or rhythm, up and down and across the plane of the working area. This programme, whilst calling for no deviation from the strength of the horizontal and vertical as structural elements, gives rise to unexpected diagonal and curvilinear energies within the resultant gestalt.

Both the exhibited paintings and the accompanying drawing share the same dimensional information, laid out in the same left to right column sequence – 6/8/10/9/7/5.
They are from a series in which six contiguous vertical columns are positionally interchanged according to certain rules and limitations (one function of which is to limit the realisation down from 720 possibilities. The arithmatic progressions mark off each column with horizontals ; ten in one column, nine in another, on down to five. These intervals establish the dimensions and positions of alternate black and white planes. Two differing first intervals head the columns left and right of centre,

Keith Richardson-Jones

to introduce a further element of asymmetry and to intensify the prospect of surprising configurations.

Series 288 (so called as the initial drawings were made with the 288 eighth of an inch units in a 36 inch length) depends then for its mechanics, on elementary calculations which are chosen for the directness with which their visual layout can be 'read'. The constituent column divisions remain discernable although obscured to a degree, optically, by the alternations of the black and white planes and the phasing in and out of horizontal alignment, of one set of column intervals against another.

These six canvases do not comprise a finite set and are not mutually dependant, inspite of their shared information and close similarities. Each painting is primarily an individually complete work. Seen as a set there is no particular viewing sequence but when seen together, common factors make certain groupings more informative than others. e.g. those paintings sharing the same column sequence, or in the case of the exhibited pair, having not only the same column sequence but absolutely identical information except for the one crucial difference. How much to reveal by analysis, in catalogue notes, remains an insoluable dilemma. The equation is to set this restraint against leaving scope for the viewer.

Context : In paintings made immediately prior to these planar works, linear forms, each with one of two signifying colours, marked the position in vertical columns, of *interspaced* arithmetic and geometric intervals. Succeeding the black and white paintings exhibited here, work is in hand on further linear schemes in which the same or differing number progressions of *Series 288* are run *across* one another in the vertical and horizontal planes — one in each plane — to form a diagonally expanding grid. A critical feature of this last group is the point or points at which differing number systems coincide.

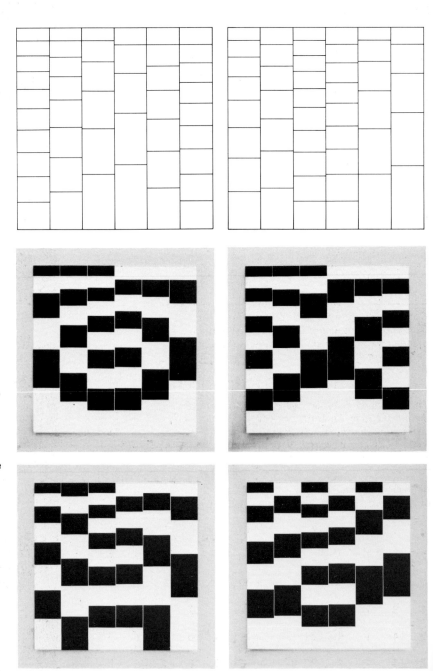

Right (*left column*) Drawing with two related paintings. Series 288 10/8/6/5/7/9

Right (*right column*) Drawing with two related paintings. Series 288 8/7/10/9/6/5

Drawing for Series 288 24/18 (ii) 6/8/10/9/7/5 1977 ink/paper 50×50cm

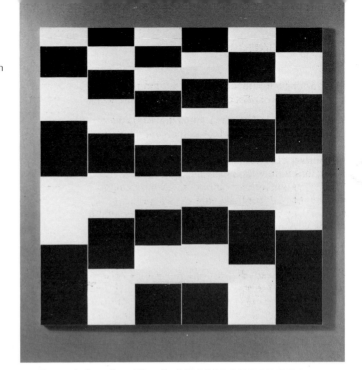

Two paintings (i and ii) series 288 24/18 6/8/10/9/7/5
1975 acrylic on canvas 80 x 80 cm

Column sequence depends on the differences
between the number of divisions in adjacent pairs,
dispersed symmetrically each side of the vertical
centre. Hence in the exhibited drawing :-
2 2 1 2 2
 i.e. 6 (2) 8 (2) 10 (1) 9 (2) 7 (2) 5.

These number arrays show the inter-relationships of
six possibilities (laid out initially for a set of drawings
of rectangular format), the first three of which show,
in this wider context, the sequences for the work in
this exhibition and catalogue.

differences between number of divisions in adjacent pairs						column positions					
2	2	1	2	2		6	8	10	9	7	5
2	2	1	2	2		10	8	6	5	7	9
1	3	1	3	1		8	7	10	9	6	5
1	3	1	3	1		9	10	7	8	5	6
2	4	1	4	2		8	6	10	9	5	7
2	4	1	4	2		8	10	6	5	9	7

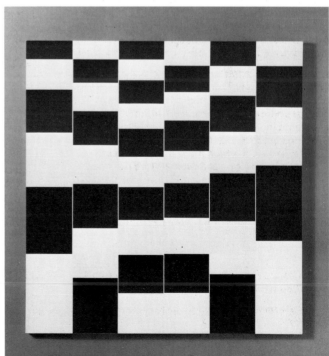

Jean Spencer

Fig. 2

Fig. 1 Relief (4 units) 1971

The four works in this exhibition were completed in 1970 and first shown at the Arnolfini, Bristol. (fig. 1).

In the catalogue for the exhibition I attempted to give a simple, logical account of the formal organisation of my work at that time :

'My painting is concerned with sequences of change.
For example :

An element (in painting : dimension, tone, hue . . .)
changes value (becomes larger/smaller, lighter/darker . . .)
within determined limits (extremes of value).

A form is composed of two or more elements ;
the juxtaposition of two or more forms constitutes
a structure, each element of which can change in value.

All information relating to the structure is contained within
the unit (single instance) ; all change is recorded in
the sequence (more than one unit, series).

A single numerical system generates the structure and controls
the direction and rate of change for each element.'

The structure of these four reliefs was generated by a grid of changing horizontal and vertical relationships, from which four 'single instances' were extracted. (fig. 2)

Jean Spencer

Above Fig. 3

Top right Fig. 4 Double Square Relief No 2 (Varese) 1977 hardboard and acrylic

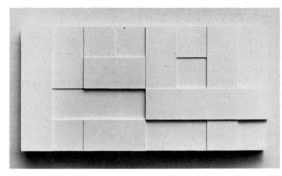

1942 Born. Studied at Bath Academy of Art, Corsham.

Exhibitions include:

1965 Bear Lane Gallery, Oxford. 1967 Axiom Gallery, London. *Unit, Series, Progression*, Arts Council Constructions, Arts Council (tour continues). 1969 University of Sussex, Brighton. *System*, Amos Anderson Museum, Helsinki. 1971 *Matrix*, Arnolfini Gallery, Bristol. 1972 *Systems*, Whitechapel, and Arts Council tour. 1973 Plus Kern, Ghent (with Malcolm Hughes). *Systems 2*, School of Architecture, Polytechnic of Central London. 1974 Didsbury College of Education, Manchester. 1976 *Rational Concepts*, Kunstcentrum *Badhuis*, Gorinchem, Holland. 1977 Second Symposium IAFKG., Varese.

My work since 1970 has been a continuous re-appraisal of these and related issues. The following is an extract from a statement in a catalogue for an exhibition of drawings by Dutch and English artists, 'Rational Concepts' (1976).[3] 'These drawings are part of a series of works using two overlaid offset grids and a (legislating) matrix.

The grids are defined by area, as in a chequer-board (presence/absence). The matrix orders the sequence of disjunction (where either one grid or the other is present) and conjunction (where both are present). In addition a second matrix order is superimposed which is an inversion of the first (positive/negative).

There are four structural variables within the system : 1) the grids 2) the relation of the grids to each other 3) the position of the matrix relative to the grids 4) the ordering of the elements within the matrix.' (fig. 4).

More recent works have reduced the level of complexity still further : to simple relations of presence/absence, opposition, exclusion, transformation. In this way it is possible to display all permutations within a particular configuration of grids, and through the complete series reveal the nature of the system.

Jean Spencer.

[1] Catalogue for 'Matrix', Arnolfini, Bristol. 1971
[2] For a much fuller explanation see 'Systems' catalogue, (Arts Council of Great Britain) Whitechapel, London, 1972.
[3] de volle maan 22. 'Engelse en Nederlandse Rationale Tekeningen'. 1976

Jeffrey Steele

1931 Born in Cardiff. 1959-60 Awarded French
Government Scholarship. Worked in Paris
1969 Co-founded the Systems Group of artists. Teaches
at the Portsmouth Polytechnic.

Exhibitions include:

1961 Institute of Contemporary Arts, London. 1965 *The
Responsive Eye*, Museum of Modern Art, N.Y. 1966 *Form
and Image,* Leeds Institute Gallery, Leeds. 1967 Carnegie
International, Pittsburgh. 1969 System, Amos Anderson
Museum, Helsinki. 1972 *Systems,* Whitechapel Gallery,
London and Travelling Exhibition, *Kinetic Art,* Glyn Vivian
Art Gallery, Swansea and Travelling Exhibition.
1973 *Englese Systemstische Kunst,* Galerie Swart,
Amsterdam. *Constructive Art,* Leicester Museum and Art
Gallery. 1974 Lucy Milton Gallery, London. Galerie Media,
Neuchatel, Switzerland. 1975 'Dilworth, Kidner, Steele',
Galerie, Jacomo-Santiveri, Paris. 1976 Le Disque Rouge,
Brussels. Rational Concepts, English Drawings'
Kunstcentrum *Badhuis* Gorinchem and Museum Nijegen,
Holland. System + Program, Galeria Teatru. Studio, Palac
Kultury i Nauki, Warsaw. Systemes et Series (Estampes
Contemporaines) Musee des Beaux-Arts, Besancon,
France. 1977 Galerie Gilles Gheerbrant, Montreal. Galerie
Swart, Amsterdam. Art Generatif, Galerie Gilles.
Gheerbrant, Montreal. *Dilworth, Hughes, Lowe, Steele,*
Annely Juda Fine Art, London.

All my works have long titles – strings of
bureaucratic-style code numbers. For example the
full title of the painting reproduced in the catalogue
is :—

Sg I 62, La I 7, D III 2, M 1 0, Sy I 1, Nk I 10,
Sx I 2, F I 2, Ch II 2, Cy VIII 2.

Each number is associated with a definite
transformation within an equally definite general
system of variant and invariant possibilities. I have
often borrowed the terminology of mathematical
linguistics to try to give an exhaustive account of
some of these transformation chains and, as I
persist, these attempts take on the characteristics
of a small textbook rather than a catalogue, note or
artist's statement. Eventually, I hope to be in a
position to produce such a book but meanwhile
perhaps a more fundamental justification of the
whole process is of greater interest.
The assumption that it is possible to store and
transform the structure of an image efficiently by
means of a notational form of words and symbols
carries the implication that some objectively
verifiable knowledge content in a work of art can
replace information which is conventionally
generated either by individual choice or by chance.
The two most challenging questions arising out of
this claim are :
1. How far might the structural content of 'an art'
(in the sense of the German word 'Gestaltung'
rather than 'Kunst' be co-extensive with that of
'A geometry' as mathematically defined.
2. Can any other artistic purpose(s) be shown to be
separable from the establishment of this structural
content and, if so, what might be the relationship
between the stuctural content and this other
significance.
In addressing these questions it is remarkable that
the notion of an identity principle arises at three
adjacent conceptual levels.
The attempt to minimise subjective, contingent and
random factors implied in question 1 might be
considered as an idealistic aspiration towards some
metaphysical (Platonic) perfection but I would cite
the following sentence by Jean Piaget in support of
the contrary view. 'The subject exists because, to put
it very briefly, the being of structures consists in
their coming to be, that is, their being "under
construction" '. [1] We can avoid mistaking a system

Jeffrey Steele

under construction for its opposite, the fashionably-styled 'de-construction' process, by reference to the second, concrete phase in the cumulative evolution within the field of constructive art :—

CONSTRUCTION—CONCRETE—SYSTEM—SERIES.

I consider this development to be the most crucial and, unfortunately, the least well-understood in the whole of twentieth century art. The metaphysical referent in the earlier, utopian, constructivism is rendered superfluous through the abandonment of ostensive conventions and the identification of the structural content of a work with its concrete material relations so that it becomes its own most efficient notation. The classical semiotic interval between signifier and signified is closed.

A similar approach to question 2 leads to a second identity principle : the meaning of a given system is identical with its social use. The abandonment of the idealist position leaves us with no possibility of locating the significance of a work of art outside the political context of its construction, diffusion, conservation, destruction. Or if we make the attempt to do so, we resemble those '... in our country who asserted that the railways left to us after the October Revolution were bourgeois railways, that it would be unseemly for us Marxists to use them, that they should be torn up and new, "proletarian" railways built. For this they were nicknamed "troglodytes" ...'. [2]

Finally there is an anology between the manner in which a work of this kind transmits ideas and the quasi-catalytic function of an identity element in a group theory or an identity equation in algebra. Between a given work and a given environment, the elements from which both are constructed and their properties, there subsist pairs of corresponding factors which combine at the level of practical, human-sensuous activity, without change to either but in a mutually revealing way. Since prevailing economic and political conditions have tended to derange the relations between systematic and constructive art and its proper architectural object, this particular function remains symbolic and the present social use of this art is mainly critical and didactic.

Jeffrey Steele

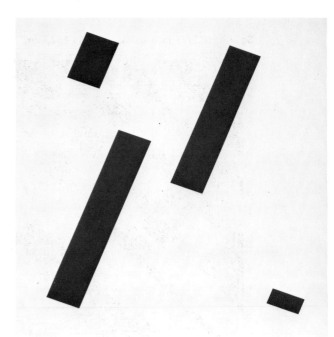

Sg IV 8 one of a set of eight prints 40 x 40 cm

Sg II 6 1974 oil on canvas 101.6 x 101.6 cm

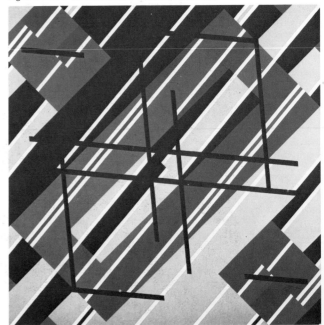

Sg I 62 1972/77 oil on canvas 152.5 x 152.5 cm

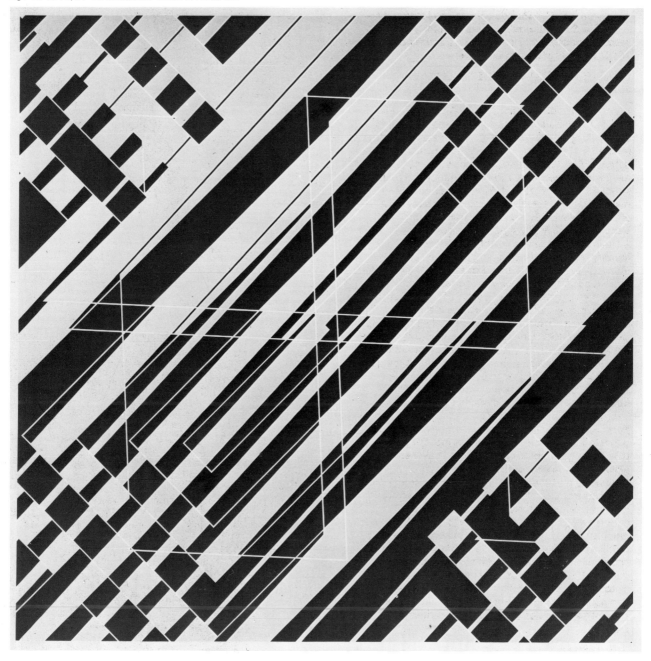

Susan Tebby

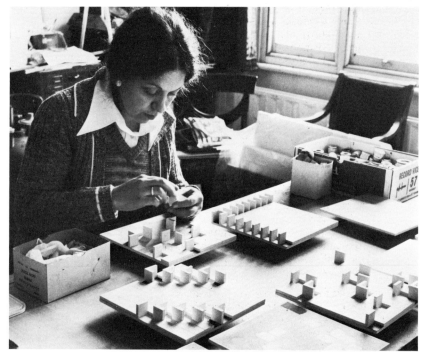

In determining which approaches are the more pertinent in the work both conceptually and visually, certain postulations must be examined in the general and the particular case.

The actual use of a system or numerical order is not necessarily the primary function. Other aspects may be as, or more, important, for example order may be changed through :

(i) process (rotation, mirrored — symmetry, etc.)

(ii) extrapolation from comparative study of behaviour of two or more dissimilar systems etc.)

(iii) interaction with intangible elements (infinity, randomness, time, sound etc.)

It also follows that areas of study which can be visualised immediately may not make sense or be interpretable by mathematical analysis.

The point at which any part of the mathematical analysis becomes coherent in visual terms and therefore developable as an artefact, is not definable in general for all instances. It is often the case that no direct way of expressing a formula or numerical order as an artefact would have any real meaning. The translation of systems and their analysis into artefacts often becomes an illustration of the behaviour of the system rather than a development of the concept of that behaviour.

1944 Born in Wakefield. 1962-66 Studied Goldsmiths College of Art. 1966-67 Studied Chelsea School of Art. 1967-70 Taught Visual Research, School of Industrial Design, Leicester Polytechnic. 1970- Teaches Sculpture, School of Fine Art, Leicester Polytechnic. 1976- Registered for Research Degree, CNAA. Lives in Leicestershire, works in London and Leicestershire. 1977 Arts Council Major Award.

Exhibitions include:

1967 *Unit-Series Progressions*, Arts Council, Cambridge/ Nottingham. 1971 Serpentine Gallery, London. 1973 *Themes and Variations*, Wolverhampton Art Gallery, Tour. *Serpentine Directions II*, Tour. 1974 *Industrial Sponsors Exhibition*, Industrial Sponsors and Arts Council, London. *Art into Landscape*, Sunday Times and Arts Council, London and Tour 1975. Lucy Milton Gallery, London. 1975 Chichester National Art Exhibition, Sussex. 1977 Whitechapel Open Exhibition, London.

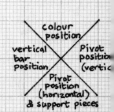

The concerns are : (a) mathematically, that the characteristics of behaviour peculiar to the system are those utilized — repeat sequences, re-current oddness/evenness, clockwise/anticlockwise motion (left/right pattern), inter relationships of sub-structures and counter movements, and (b) visually, i.e. within the artefact, that these characteristics of mathematical behaviour are amplified through specific use of space, volume, thickness of line or material, ambiguities of space-depth manifest through time sequences etc.

The question of what is considered significant in the mathematical analysis (given that it is attained and recognised) is critical. For it seems logical that it should be precisely at this point that an artefact would be made as a particular way of summarising.

The operation of a particular kind of movement within certain deliberately imposed limitations is the concern of the Relief *Permutation on 7,* 1973. There are, at once, several kinds of movement, although one is dominant ; there are also several kinds of limitations, some of which are only apparent in direct relation to the movement which transcends them.

(A) MOVEMENT

- (i) physical manipulation of pieces
- (ii) apparent 'travel' of vertical sections across moving pieces :
- (iii) up/down motion of support blocks and pivot positions
- (iv) transference of position of moving blocks row by row according to permutation, pattern defined by colour.

(B) LIMITATIONS

- (i) visual field as bound by the wall behind to the outermost surface in front, and left to right extremities as defined by edges of base-board. All visual relationships are contained within this space.
- (ii) certain pieces are physically limited in their range of movement due to position of pivots.
- (iii) only variations of this permutation which generate complete cycles of oscillation, or a half-cycle preceded by a whole cycle, are permitted.

Information in the following matrix give relative positions for four elements and two attributes, and show by combinations peculiar characteristics for certain pieces or rows :

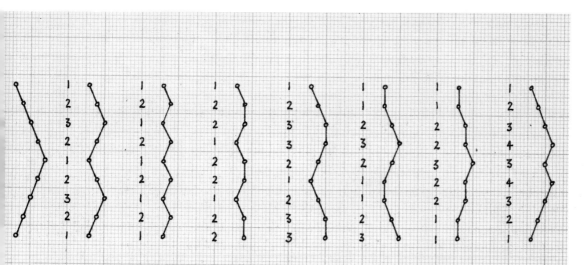

cillations given for a 9 sequence , where no interval is greater than 1

Susan Tebby

Permutation on 7 1973 silthane and alkyd, wood, formica and brass pivots 57.6 x 57.6 x 12 cm

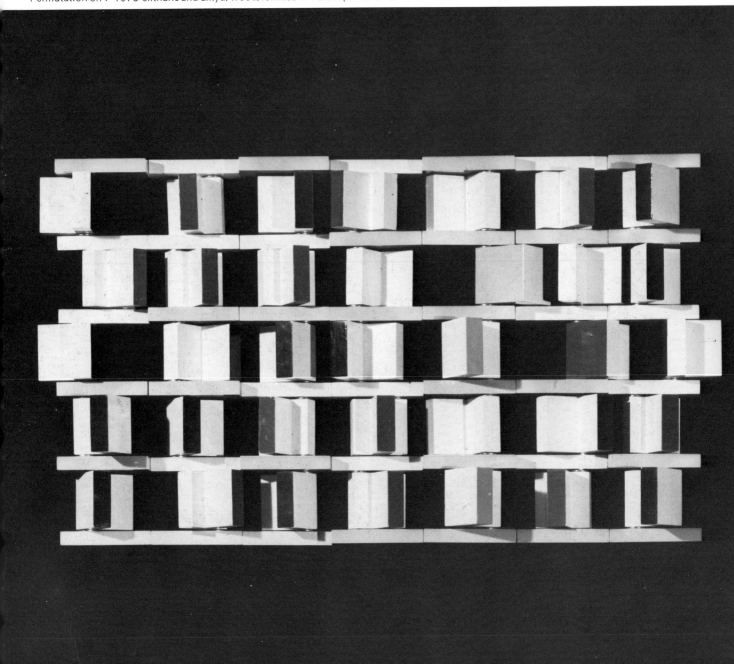

Chris Watts

Set of 11 drawings '5' 1976 58 x 58 cm

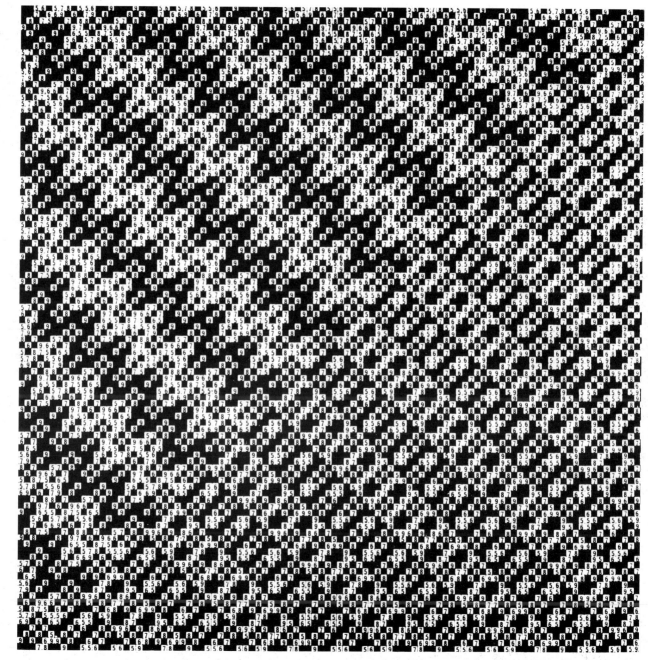

Drawing from note-book 1976-77

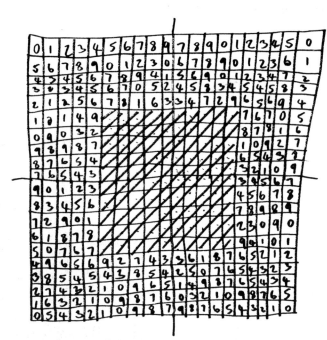

10x10 -

10x10 .

1. Introduction.

Prior to 1970 much of my art work comprised of reliefs, falling in line with the English Constructive movement. Towards the end of the 1960's, I began to doubt whether the information I wished to communicate was sufficiently accessible to the viewers in the reliefs ; it seemed that the visual elements in operation within the work at this time had to be re-evaluated.

During 1970, numbers became primary visual elements within my finished work, which by then comprised of drawings. The decimal number system became of interest because it complied well with the reasoning behind the need for change in the character of my work. In choosing a new system it was important that its elements had potential for generating new types of visual experiences and had a character which was widely known, allowing the viewer better access to the information to be retrieved from the work — the constructional history.

Numbers have ideal qualities in terms of defining locations within grid areas, in addition to possessing a serial characteristic to which the viewer is accustomed ; the latter aspect assists the process of following lines (scanning) through the work. So the number is seen as an element that satisfies certain visual and intellectual requirements.

2. Construction.

My working process can be divided into two main areas of activity ; it is important to outline these as my work, which in the main is comprised of drawings in series, reflects this partitioning. More clearly the activities fall into two zones.

Zone 1. The construction of the structure to be explored.
Zone 2. The uncovering of the known and unknown information found within the structure.

These two areas are further defined under the following sub-headings.
Zone 1. (a) The construction of the environment within which the numbers are placed.

Generally the environments comprise of grid structures ; these may be square, rectangular, triangular or circular. The dimension of the grid is determined by the type of activity proposed within its environs, or by predetermined proportions related to the quantity of numbers within a series e.g. the use of the sequence 0, 1, 2, 3, 4, 5, 6, 7, 8, 9 (ten numbers) in repetition within a 100 x 100 square grid.

Zone 1. (b) The nature of the placements.
These involve the process of route making through the grid. The location of the numbers follows an order discovered by counting through the grid in their consecutive sequence. The data positioning is, in the main, linear and can be quite varied, as long as the sequence continuity remains unbroken. At times the linear form fills the whole of the grid structure, forming one block, or alternatively forming smaller blocks within the grid structure. The block combinations as basic units are often manipulated further, according to repetitive processes, mirror images, axial changes or other procedures.

Zone 2. (a) Variation in aspects of examination.
The examination process attempts to explore the constructed structure, pointing out the sub-stratas or underlying geometries. Examples take the form of locating various groups of numbers, such as all the zeros and all the nines, specifying number blocks within the larger area that have the same configuration or looking for the position of serial routes that repeat.
One example of the intentions here would be to construct a square grid area of 20 x 20 spaces that is filled with a repetition of the sequence 0, 1, 2, 3, 4, 5 in a diagonal order, starting from the top left hand corner and ending in the bottom right hand corner, which is examined in terms of the position of sequences that repeat, on the horizontal axes from the top to the bottom. What is interesting is that with very simple shifts in the uncovering process unexpected visual combinations emerge.

The zones defined here are not seen as being permanently fixed. The boundries may well change as I absorb more information, experience and as further ideas are programmed through the definitions.

Drawing No. 1 of a duet, Diagonal Loading 1977

Drawing No. 2 of a duet, Diagonal Loading 1977

1947 Born in England. 1966-69 Studied at Goldsmiths' College of Art, London. 1969-71 Ohio University, School of Art, USA. 1973 Returned to Britain.

Exhibitions include:

1971 Ohio University, USA. 1972 University of Rhode Island, USA. Hobert College, USA. Newport Art Society, USA. 1975 Museum of Modern Art, Oxford. Institute of Contemporary Arts, London. 1977 Northern Arts, Newcastle. Cornish School of Allied Arts, Seattle, USA. *Visual Objectives*, Harlow. Art Research Center, Kansas City, USA. 1978 *Constructive Rationale* Polytechnic of Central London.

Gillian Wise Ciobotaru
Winged Net, Shadow Trace, Yellow and Blue 1976 paint and ink on paper 60×60cm

Gillian Wise Ciobotaru
Opening Movement 1976 paint on paper 60×60cm

Norman Dilworth
Single Line 1976 wood 153×168×68cm

John Ernest
Relief Painting: Iconic Group Table 1977 89.5×89.5×8cm gouache on wood structure lent by the artist

Anthony Hill
The Nine – Hommage a Khlebnikov No. 1 1975 relief laminated and engraved plastic 86.3×86.3cm

Anthony Hill
Linear Construction B Large Red 1972 engraved laminated plastic 61×61cm

Malcolm Hughes
Three Unit Relief/Painting wood, hardboard, PVA and oil 58.6×243.8cm

Malcolm Hughes
Three Unit Relief Drawing for 1973 pencil and gouache 38.5×60cm

Michael Kidner
Analysis of a Wave Pattern 1973 aquatec paint on cotton duck stretched over hardboard 91.5×91.5cm

Tony Longson
CRS 1976 milled perspex and cellulose paint 60×60×10cm

Peter Lowe
Horizontal Relief Construction No. 2 1969 perspex 41×224cm lent by the artist

Peter Lowe
System of Six Elements on Grey 1969 perspex and wood 49×49cm lent by the artist

Kenneth Martin
Chance, Order, Change 2 (ultramarine blue) 1976 oil on canvas 91.4×91.4cm

Kenneth Martin
Study for Chance, Order, Change 2 (ultramarine blue) 1976 pencil and ink on paper 26×34.5cm

Terry Pope
Transparent Construction 1977 acrylic sheet 80×55×12cm

Keith Richardson-Jones
Series 288 24/18 (i) 6/8/10/9/7/5 1975 acrylic on canvas 80×80cm

Keith Richardson-Jones
Series 288 24/18 (ii) 6/8/10/9/7/5 1975 acrylic on canvas 80×80cm

Keith Richardson-Jones
Drawing for Series 288 24/18 (ii) 6/8/10/9/7/5 1977 ink on paper 50×50cm lent by the artist

Jean Spencer
Relief (4 units) 1971 hardboard on timber support 61×61×6cm (each)

Jean Spencer
Drawing 1971 collage, dyeline, print and crayon on paper 52×67cm

Jeffrey Steele
Sg I 62 1972/77 oil on canvas 152.5×152.5cm

Susan Tebby
Permutation on 7 1973 silthane and alkyd, wood, formica and brass pivots 57.6×57.5×12cm

Chris Watts
Set of 11 Drawings: an Area of 10,000 Marks and Ten States in which the Marks 0,1,2,3,4,5,6,7,8,9 are Located 1976 58×58cm each